ZAPiRO

Pirates of Polokwane

Cartoons from *Mail & Guardian, Sunday Times,*
and *Independent Newspapers*

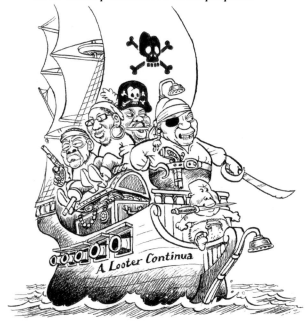

A Looter Continua

JACANA

Acknowledgements: Thanks to my editors at the Mail & Guardian *(Ferial Haffajee), at the* Sunday Times *(Mondli Makhanya) and at* Independent Newspapers *(Tyrone August, Moegsien Williams, David Canning, Zingisa Mkhuma) and the production staff at all the newspapers; my former assistant Carol Wilder and new assistant Lisa Stemmet; Bridget Impey, Russell Martin and all at Jacana; Claudine Willatt-Bate; Nomalizo Ndlazi; and once again, my family: Tevya, Nina and my wife Karina.*

First published by Jacana Media (Pty) Ltd in 2008

10 Orange Street
Sunnyside
Auckland Park 2092
South Africa
(+27 11) 628-3200
www.jacana.co.za

in association with

© 2008 Jonathan Shapiro

ISBN 978-1-77009-598-4

Cover design by Jonathan Shapiro

Page layout by Claudine Willatt-Bate
Printed by CTP Books, Cape Town
Job No. JAC000857

See a complete list of Jacana titles at www.jacana.co.za

For the eternal optimists among us

Other ZAPIRO books

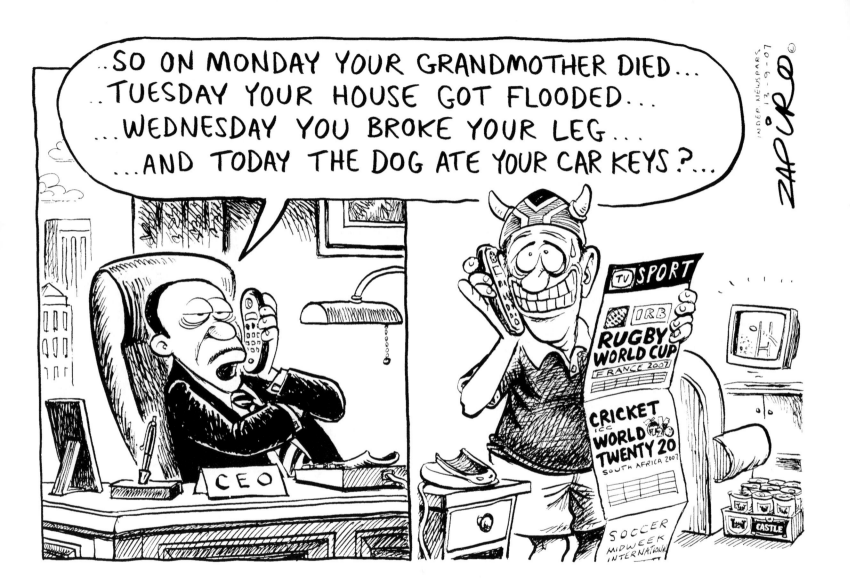

13 September 2007

Mouth-watering month of sport ahead

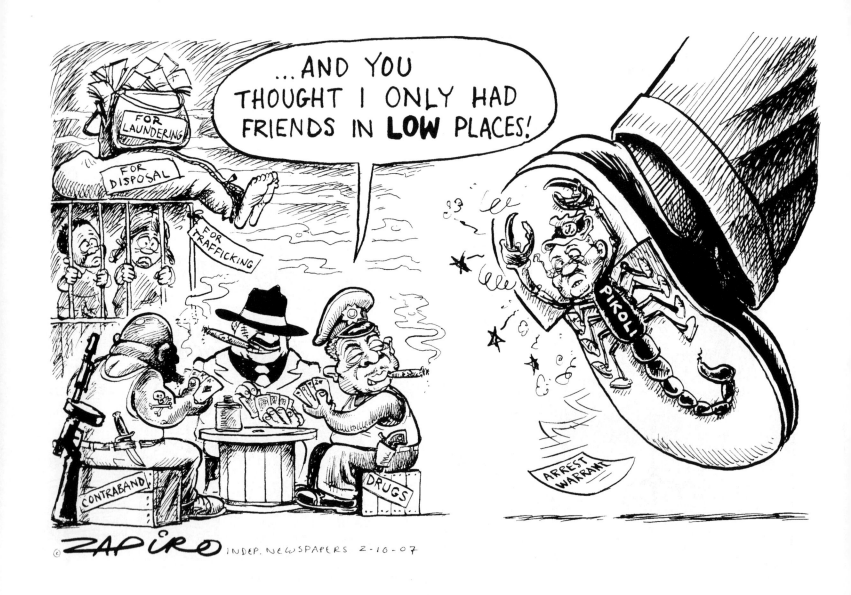

2 October 2007

National Police Commissioner Jackie Selebi has long been linked
to a criminal syndicate. But as the National Prosecuting in Authority
is about to arrest him, President Mbeki suspends NPA head Vusi Pikoli.

6

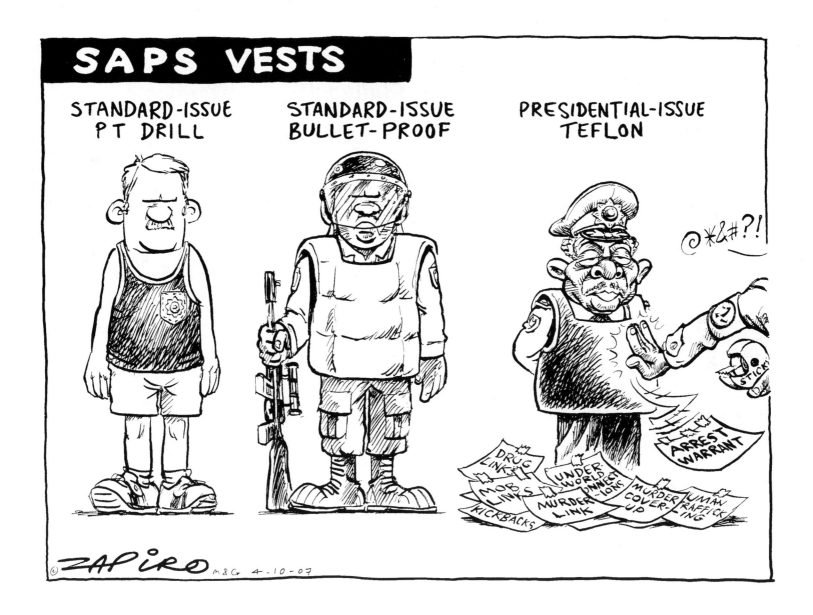

4 October 2007

He's Mbeki's old ally. Four warrants for his arrest
have been quietly quashed. He says he'll never be arrested.

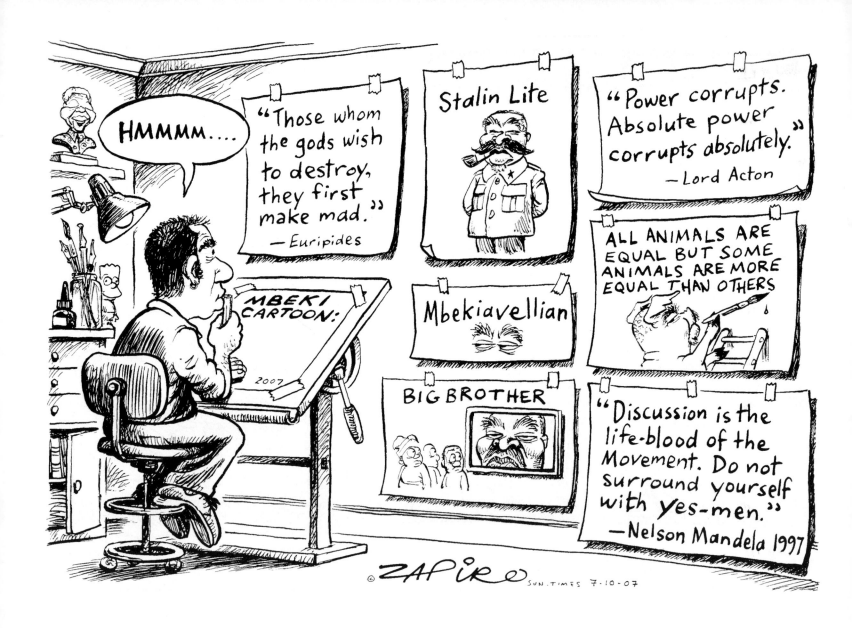

7 October 2007

Is the president abusing state apparatus, fast-tracking Zuma's prosecution while quashing Selebi's? Official denials ring hollow.

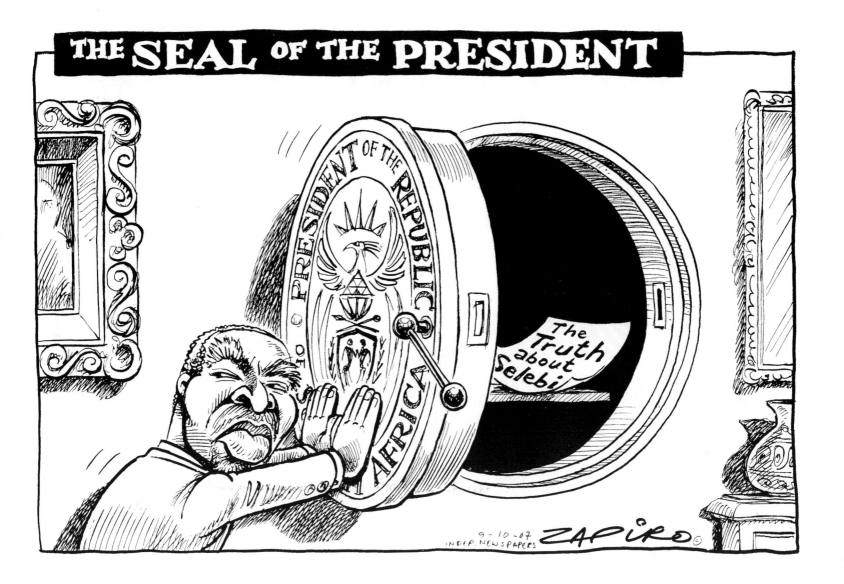

THE SEAL OF THE PRESIDENT

9 October 2007

Media exposé: Mbeki knew all about Selebi's crime links when he said he didn't. And he knew about the warrants when he denied knowing.

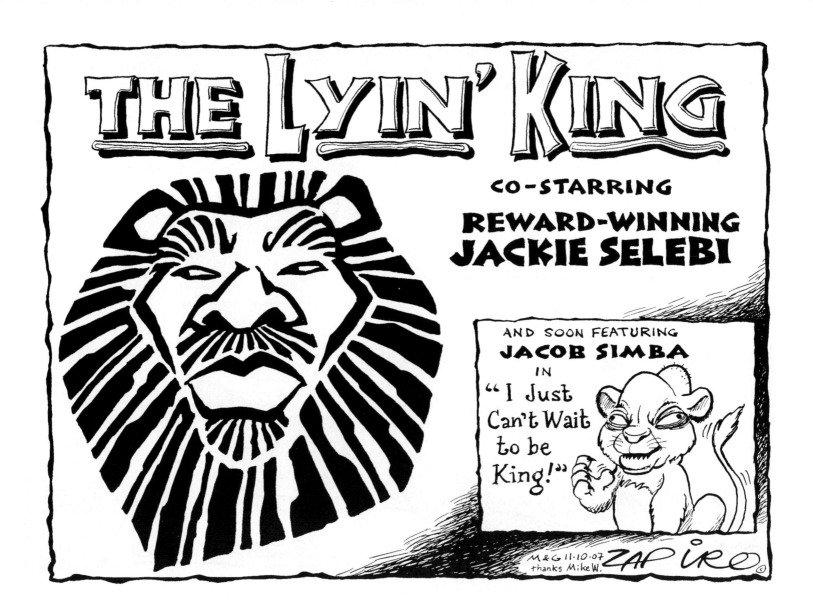

11 October 2007

10

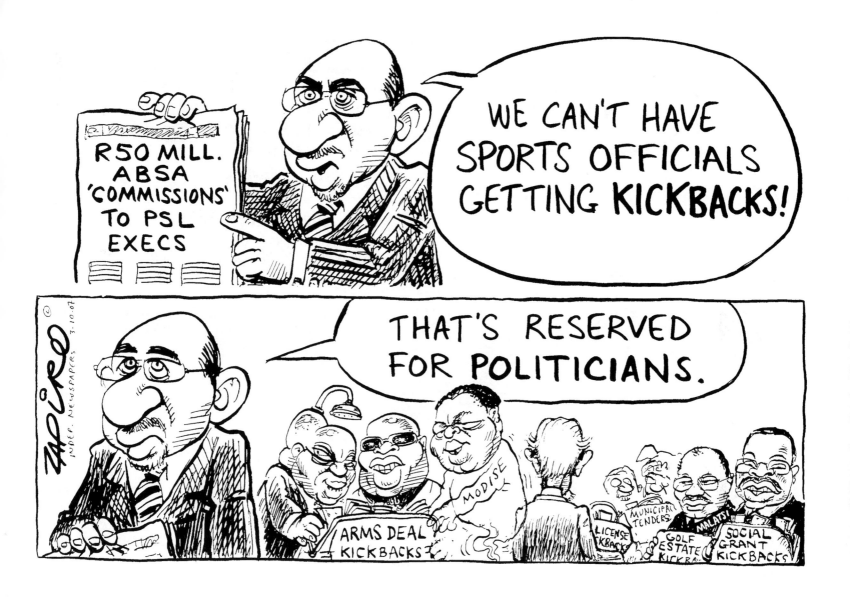

Five Premier Soccer League bosses will get R10 million each from
Absa Bank for cutting a sponsorship deal. That's corrupt, says
the Finance Minister, and parliament agrees. Irony, anyone?

3 October 2007

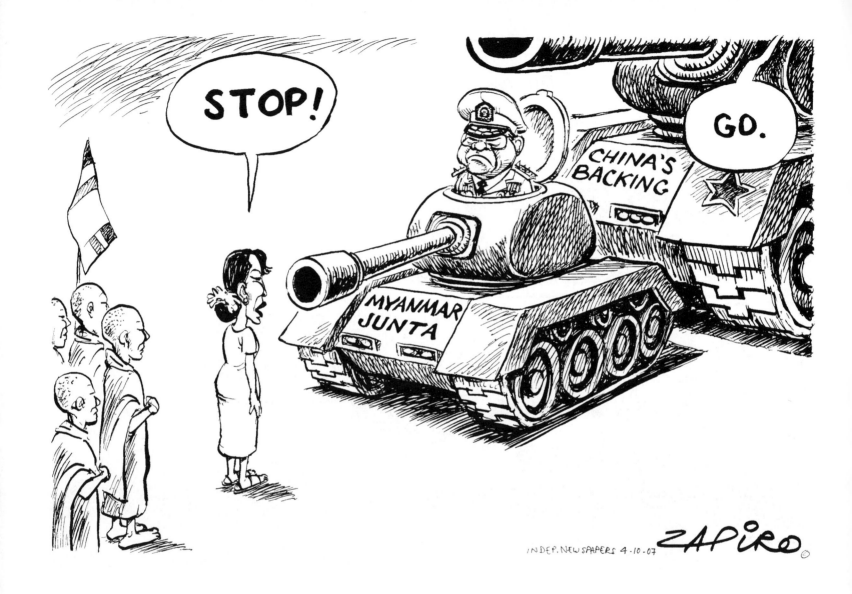

With Burmese opposition leader Aung San Suu Kyi under
house arrest, Buddhist monks lead huge pro-democracy marches
in defiance of General Than Shwe's dictatorship. Scores are killed.

4 October 2007

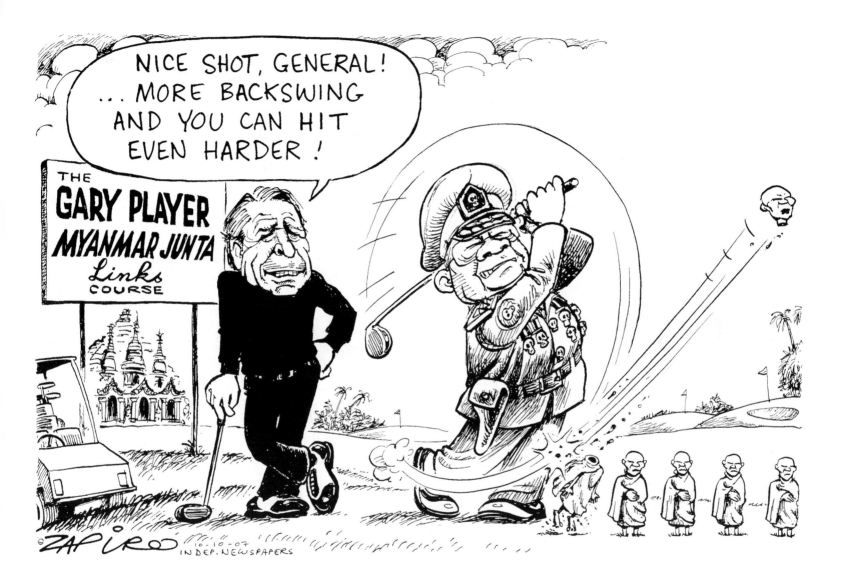

10 October 2007

Gary Player's company built the Pun Hlaing Golf Club
in Myanmar (Burma) where junta generals hang out

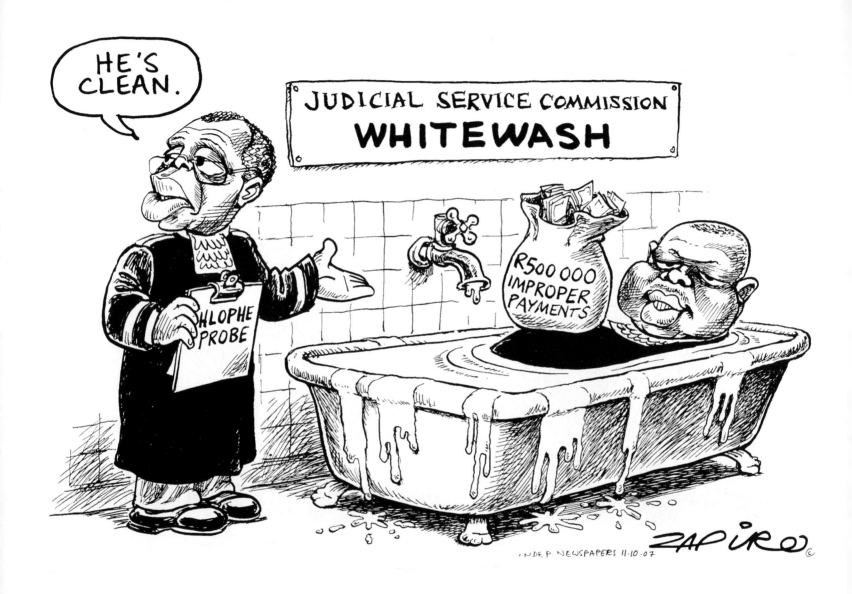

Cape Judge President John Hlophe accepts payments from a private company,
Oasis, and then didn't recuse himself from a case involving Oasis. 'Impeach him'
is the widespread call. Chief Justice Pius Langa heads the JSC wimp-out.

11 October 2007

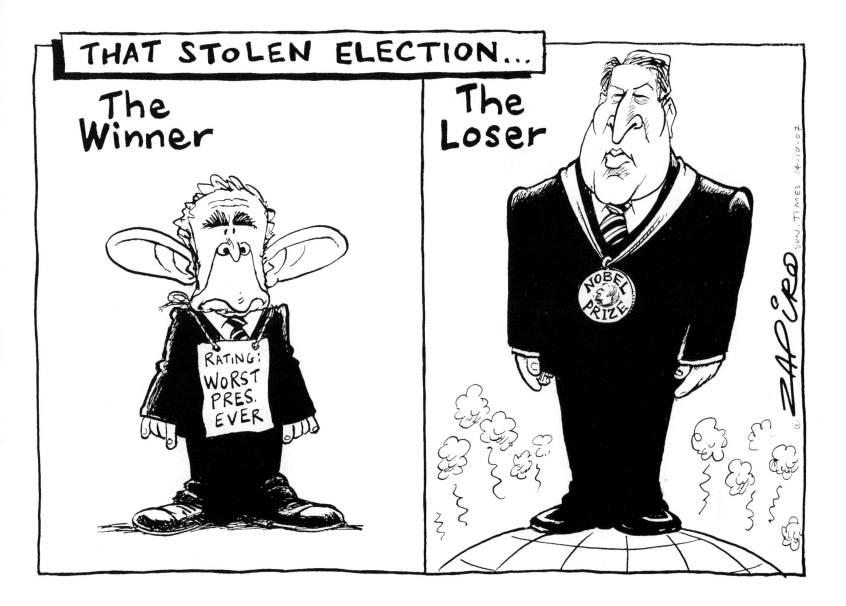

14 October 2007 — Anti-global warming campaigner Al Gore is the co-winner of the Nobel Peace Prize

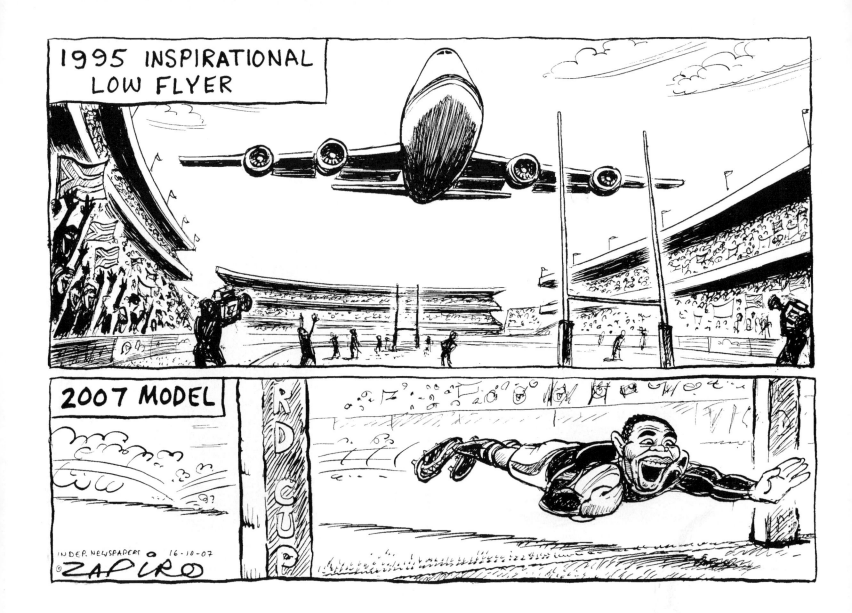

16 October 2007

Springbok speedster Bryan Habana electrifies the Rugby World Cup in France, his
two semi-final tries against Argentina confirming that SA will play England in the final

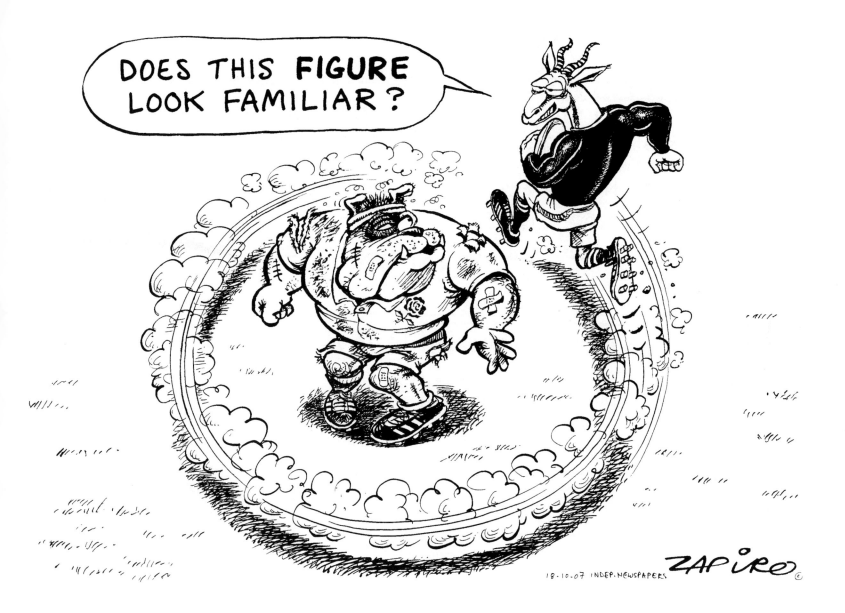

18 October 2007

A reminder that in their earlier pool match,
the Boks posted 36 points to England's big fat zero

Dear President Mbeki, do you remember?....

BLACK WEDNESDAY

1977 — 19 October — A NATION SILENCED.

APARTHEID REGIME CRACKS DOWN ON STUDENT LEADERS AND BANS PRO-LIBERATION NEWSPAPERS. EDITORS ARRESTED.

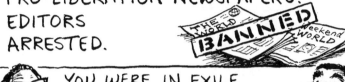

YOU WERE IN EXILE FIGHTING THE STRUGGLE UNDER TAMBO'S LEADERSHIP

1987 — A NATION IN FLAMES.

STATE OF EMERGENCY. THOUSANDS OF ACTIVISTS DETAINED. NEWSPAPERS CENSORED AND BANNED.

YOU LED TALKS WITH AFRIKANERS IN DAKAR.

1997 — A NATION IN TRANSFORMATION.

FREEDOM! DEMOCRATIC INSTITUTIONS BEING CREATED UNDER A SUPERB NEW RIGHTS-BASED CONSTITUTION.

AT THE ANC NATIONAL CONFERENCE, PRESIDENT MANDELA GIVES A VEILED WARNING AGAINST YOUR AUTHORITARIAN TENDENCY.

2007 — A NATION IN FEAR.

GOVERNMENT ABUSE OF STATE ORGANS TO HARASS OPPONENTS, SHIELD CRONIES AND COVER UP CORRUPTION. CRITICS SILENCED. EDITOR TO BE ARRESTED.

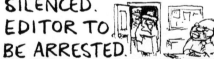

ZAPIRO
WEDNESDAY 17 OCTOBER 2007
INDEP. NEWSPAPERS

YOU HAVE BECOME WHAT YOU FOUGHT AGAINST.

STALIN LITE

Outrage sparked by imminent arrest of *Sunday Times* editor Mondli Makhanya and his deputy for the 'theft' of the medical records of Health Minister Manto Tshabalala-Msimang. The paper had published a damning report on the minister's boozing while in hospital.

17 October 2007

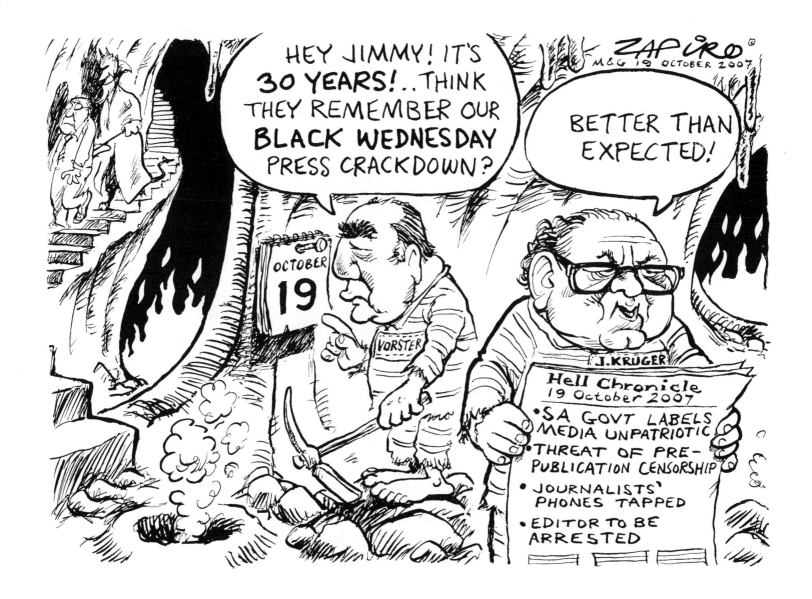

19 October 2007

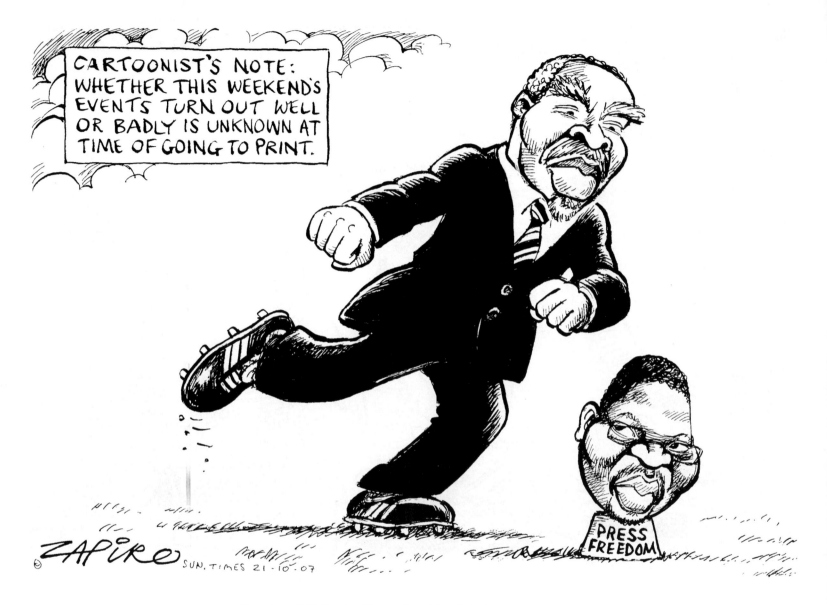

Questions: Will *Sunday Times* editor Mondli Makhanya be arrested?
Will the Springboks win the World Cup? Answers: Makhanya is not arrested.
And

21 October 2007

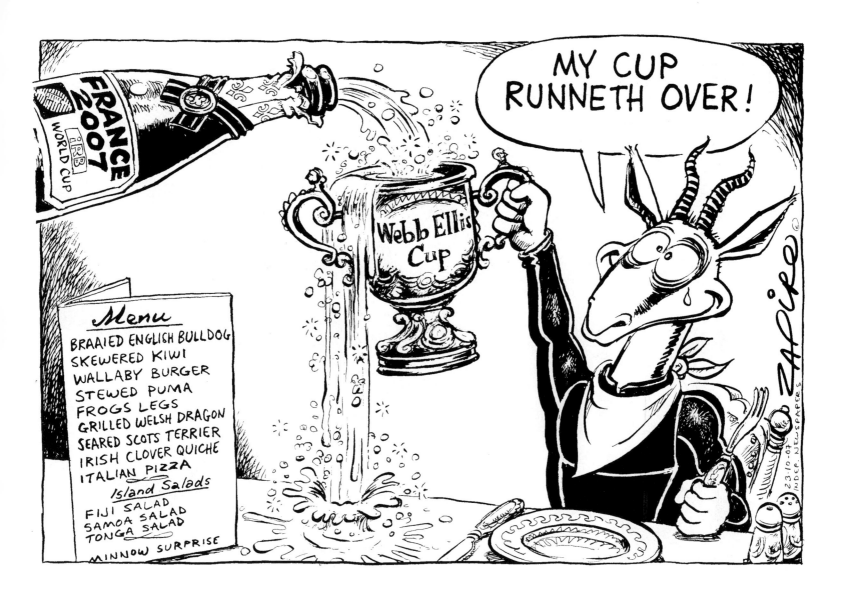

23 October 2007 ... The Boks beat England 15–6

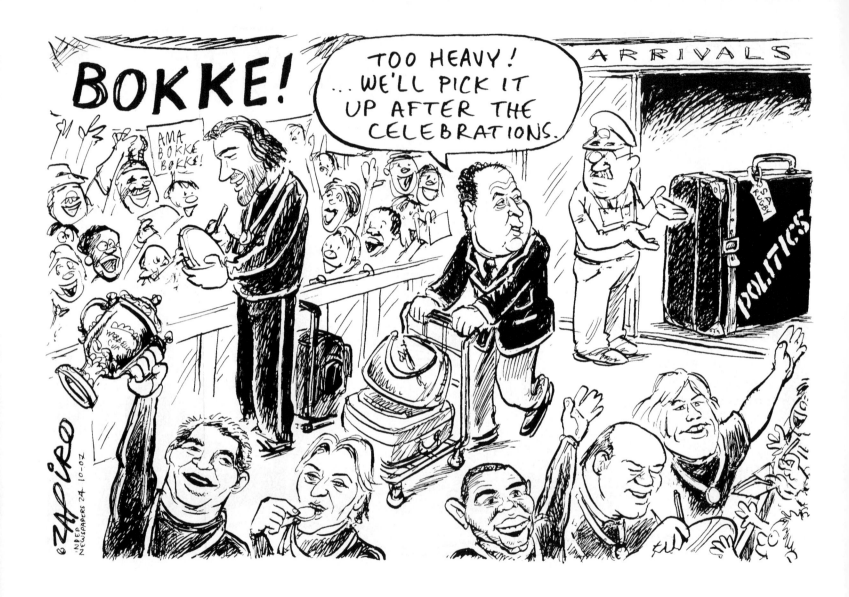

24 October 2007

Amid the euphoria, debate about transformation: only two black players featured in the final, and coach Jake White learns that SA Rugby has advertised his job

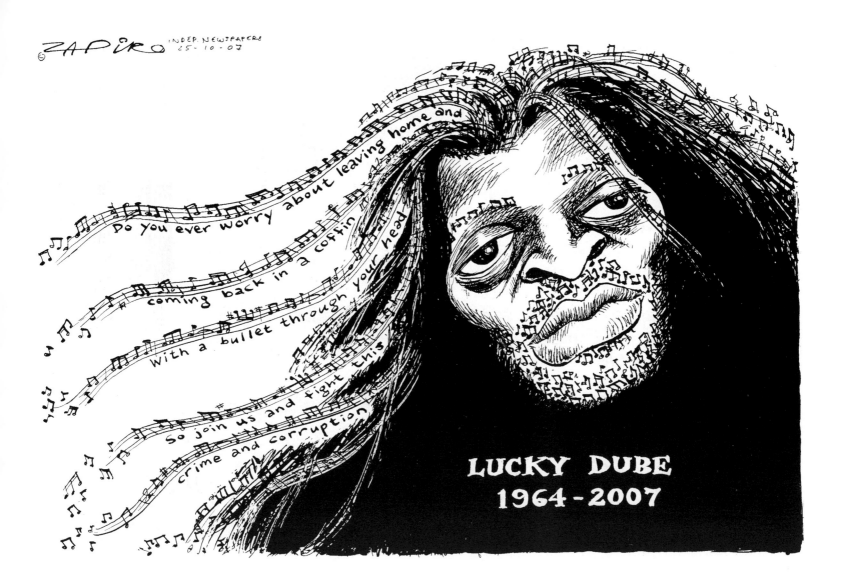

25 October 2007

Reggae icon killed during bungled car hijacking

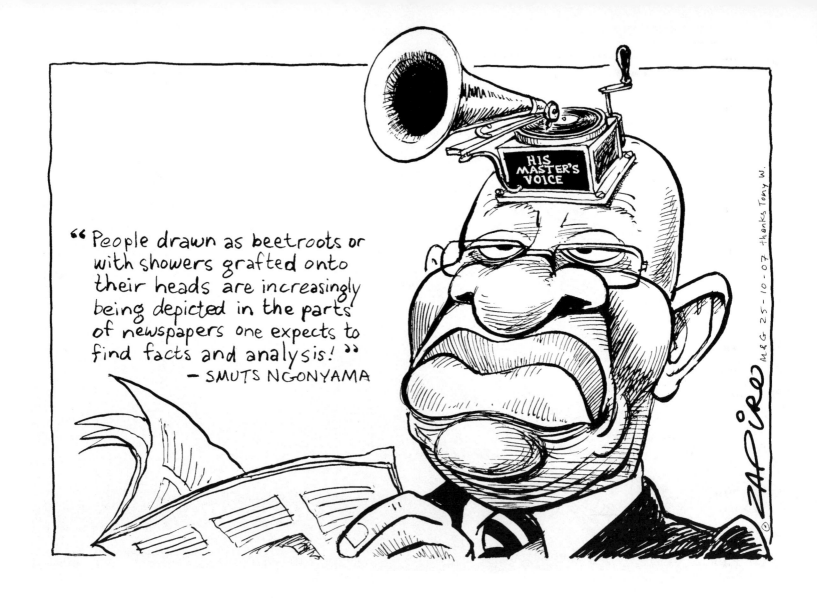

" People drawn as beetroots or with showers grafted onto their heads are increasingly being depicted in the parts of newspapers one expects to find facts and analysis! "
– SMUTS NGONYAMA

HIS MASTER'S VOICE

M&G 25-10-07 thanks Tony W.

25 October 2007

As the ANC moots a tribunal to regulate the media, the party's information head gives the input

24

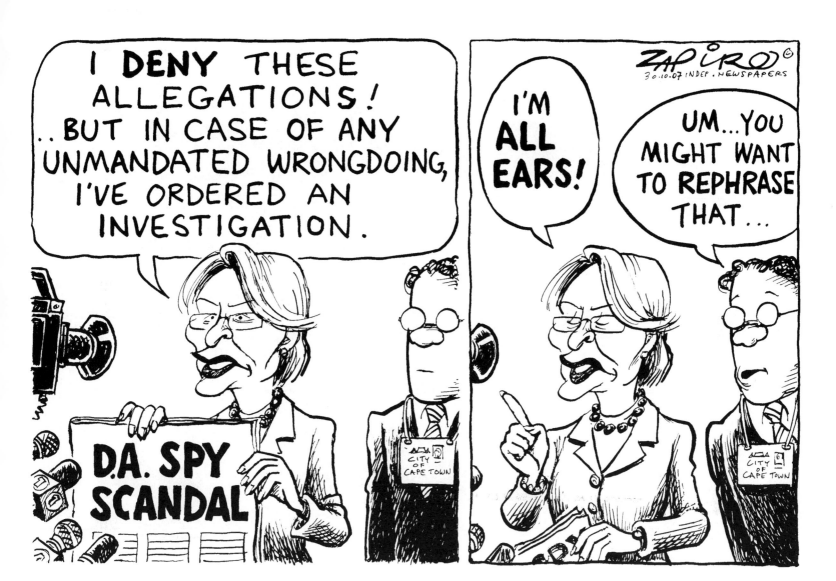

30 October 2007

Democratic Alliance leader and Cape Town Mayor Helen Zille appoints an
inquiry into ANC claims that City officials spied on opponents at ratepayers' expense

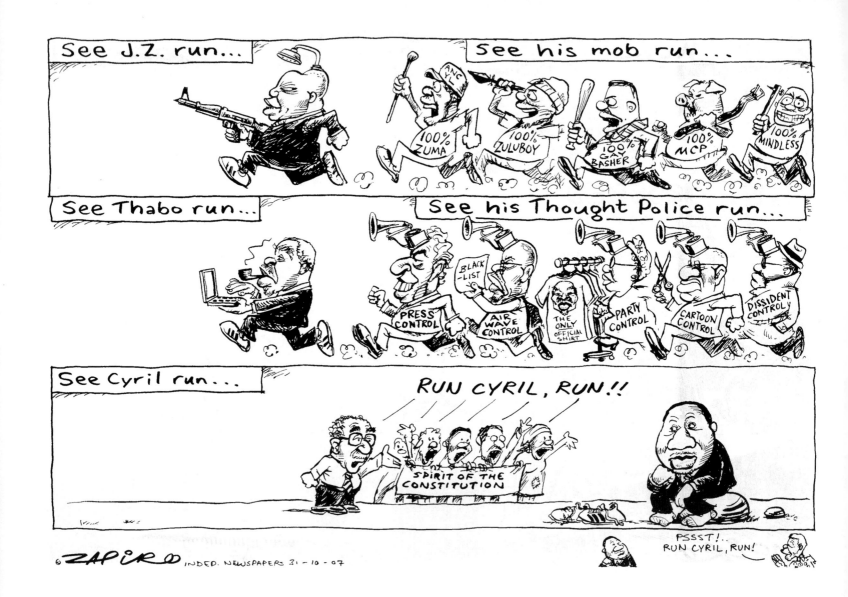

31 October 2007

Seven weeks left in the ANC presidential race. Respected businessman
Cyril Ramaphosa is coy about reports that a Cape Town branch has nominated him

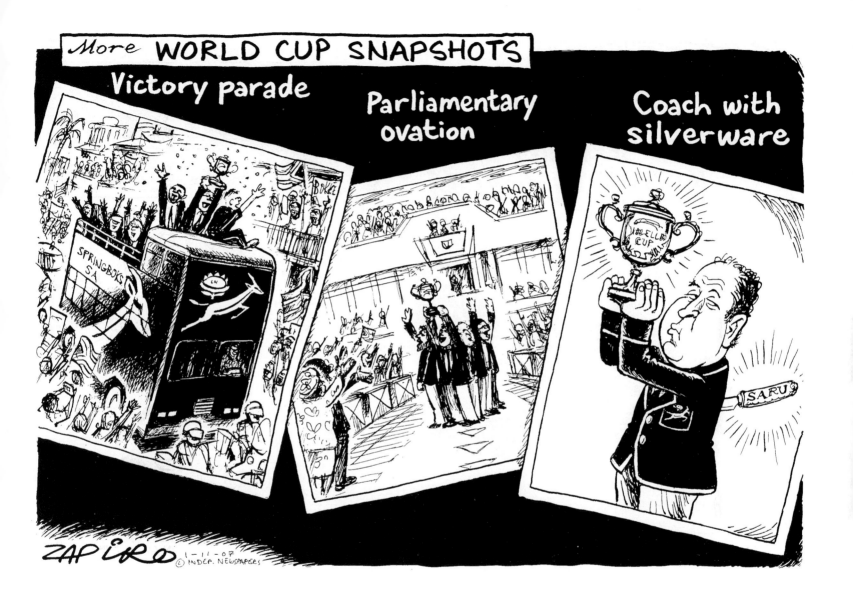

More **WORLD CUP SNAPSHOTS**

Victory parade

Parliamentary ovation

Coach with silverware

ZAPIRO

1 November 2007

As the Boks get a hero's welcome, Jake White
resigns, citing irreconcilable differences with rugby officials

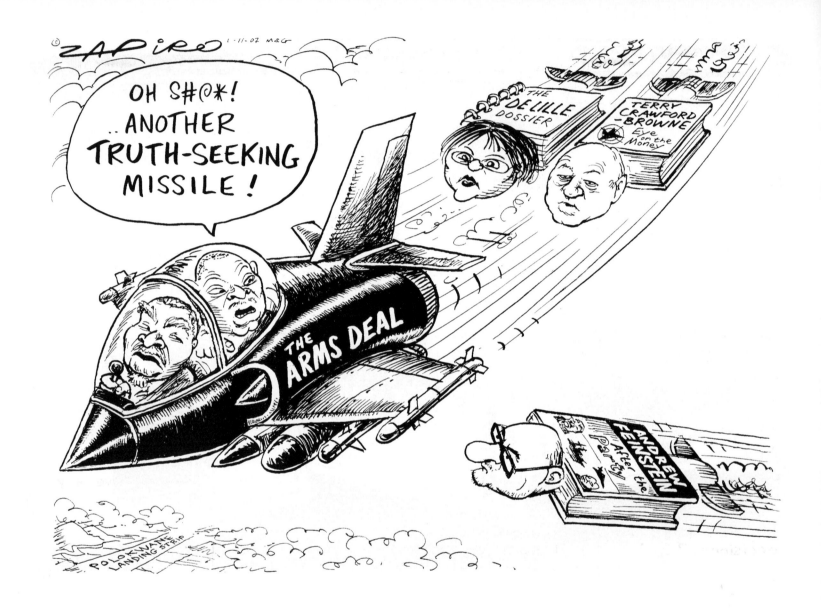

1 November 2007

Minister of Defence Mosiuoa 'Terror' Lekota may well exclaim. A new book
cites his belligerence in covering up the dodgy dealings of both Zuma and Mbeki.

Name:
Jake

Feeling rejected. Looking 4 friends in New Zealand, Aussie or Wales

Name:
Gary

Jake try Burma (Myanmar? –I'm never sure!) I got a gr8 place, we'll pla a round 2gether whenever the bald guys in the orange towels aren't being shot on the fairway.

Name:
Jackie

Looking 4 friends, I'm not fussy. Some of mine R in the slammer 4 bigtime dealing and rubbing guys out. I don't ask too many questions. Capiche?

Name:
Badih

Hey Jackie lets hook up!!!! I'll B yr Badih!!! Geddit?? I can do with a china, some1 is bugging me!!!!

Name:
Cyril

All friends who've been contacting me: thanks but I need space. Got 1 of those big do-I-don't-I decisions 2 make

Name:
Jacob

If U R looking 4 a homophobic sponging chauv, I will B yr pal. O, and can U get me a machine gun? And a hacksaw 4 this #@*& shower!!!!

Name:
Manto

Any1 kno if theres a kleptomaniacs anonymous? A friend in alcoholics anon says there is

Name:
Thabo

Looking 4 friends. I don't have any right now.

4-11-07
SUN. TIMES
ZAPIRO ©

4 November 2007

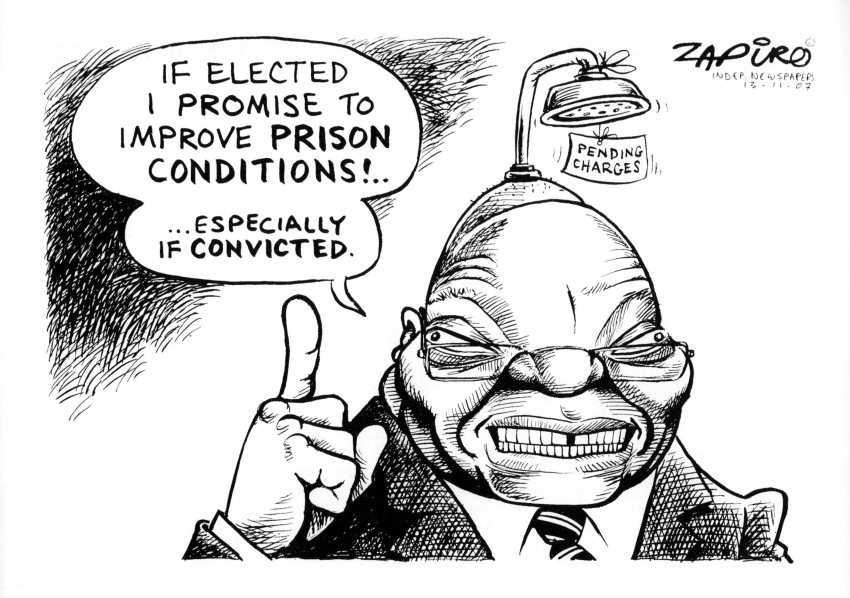

13 November 2007

Court judgement admits disputed documents as evidence. Now tax evasion and money-laundering are added to the charges of corruption and fraud.

WELCOME ON BOARD SHOESTRING AIR!

WE WILL SOON BE TAKING OFF, UNLESS WE SKID OFF THE RUNWAY.

IN CASE OF AN ENGINE FALLING OFF, SIMPLY INFORM ONE OF THE CABIN CREW.

IF YOU ARE SEATED NEXT TO AN EXIT, YOU MAY BE ASKED TO ASSIST WITH ANY INFLIGHT WING REPAIRS.

NOW PLEASE FASTEN YOUR SEATBELT, IF YOU HAVE ONE.

WE WILL SHORTLY BE SERVING A LIGHT SNACK. IN THE EVENT OF A FIRE IN THE REAR OF THE AIRCRAFT...

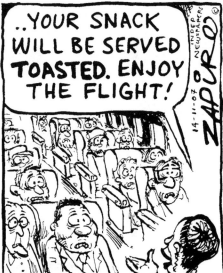

..YOUR SNACK WILL BE SERVED **TOASTED**. ENJOY THE FLIGHT!

14 November 2007

An engine falls off a Nationwide Boeing 737 during takeoff, shortly after another plane skidded off the runway

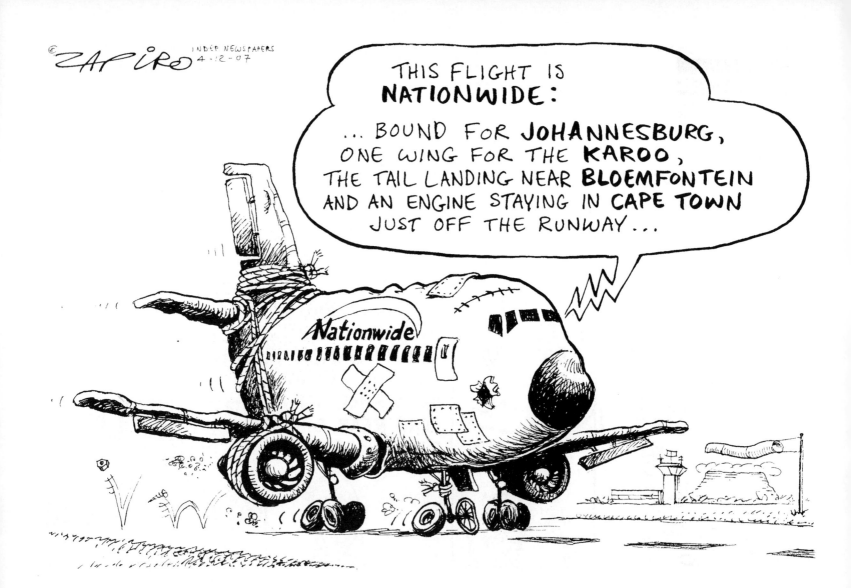

4 December 2007

After aviation authorities inspect Nationwide
aircraft, the airline's entire fleet is grounded

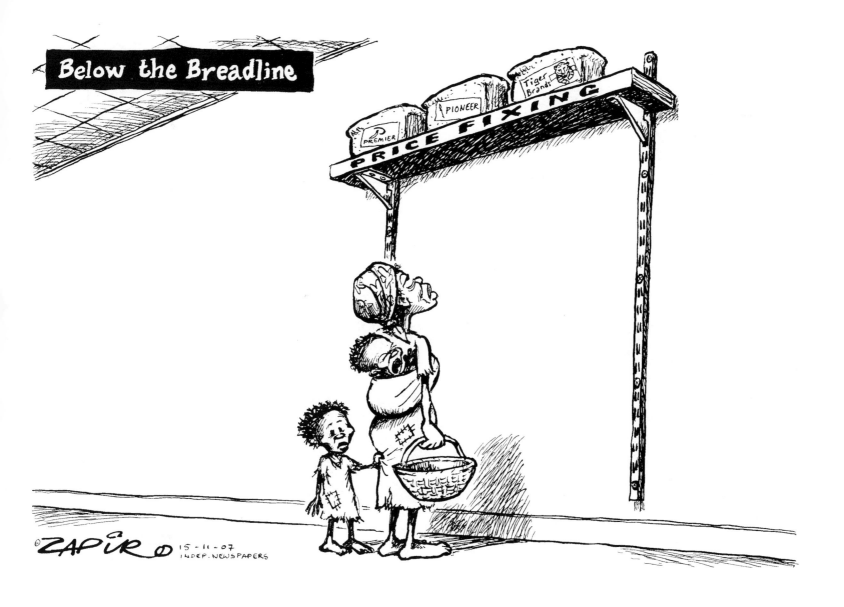

Below the Breadline

We've been paying too much for bread.
Rival producers have been caught fixing the price.

15 November 2007

33

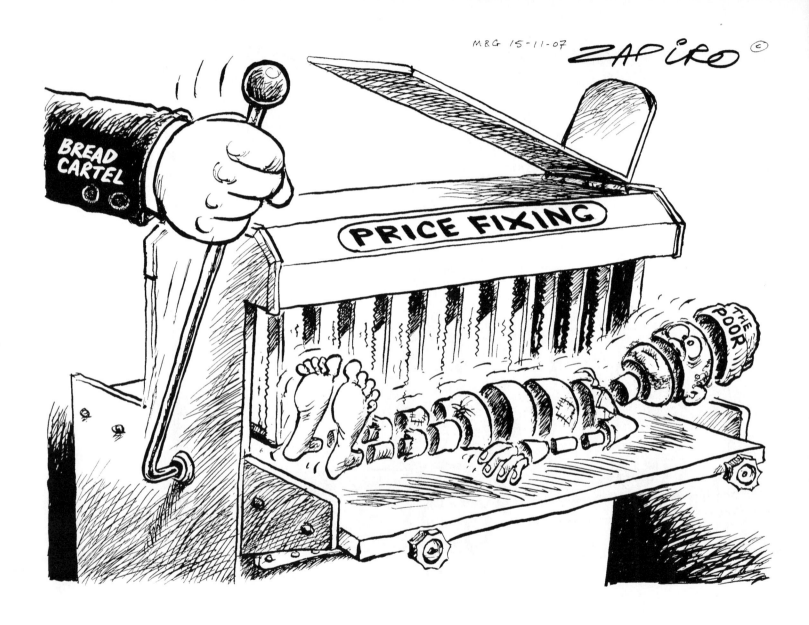

And we'll keep on paying as ringleader Tiger Brands absorbs
the R99 million fine imposed by the Competition Commission

15 November 2007

34

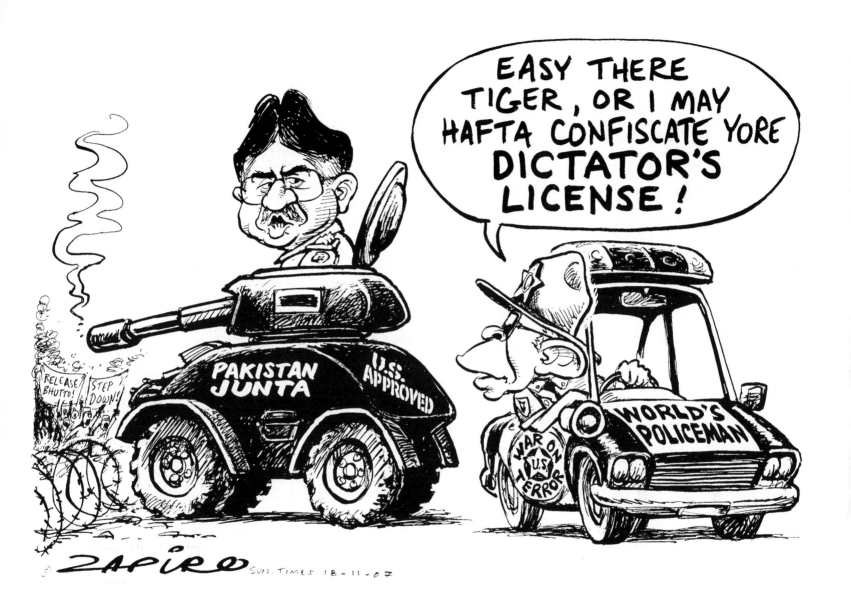

18 November 2007

Imposing emergency rule in the run-up to Pakistan's election, military ruler
Pervez Musharraf draws international condemnation and even a rebuke from a loyal ally

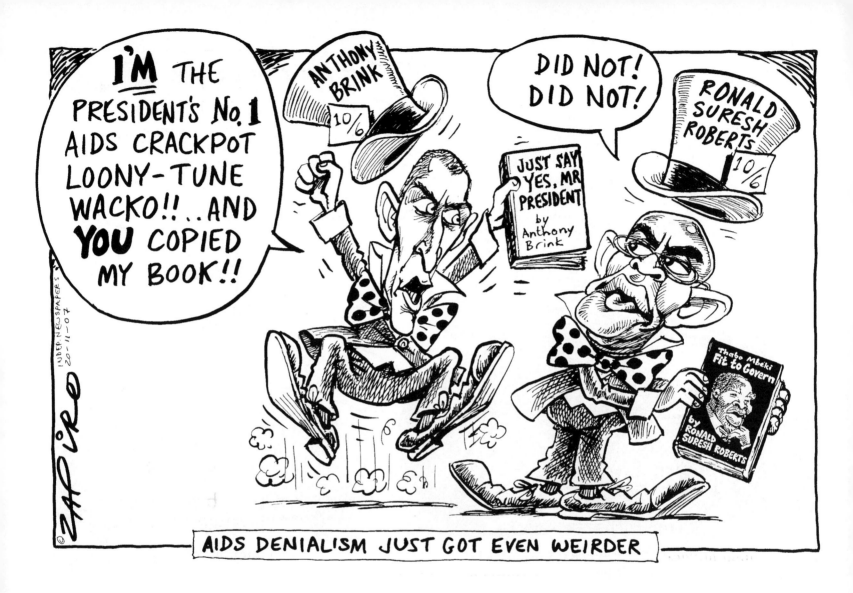

The lawyer who persuaded Mbeki to become an
Aids dissident versus Mbeki's bootlicking biographer

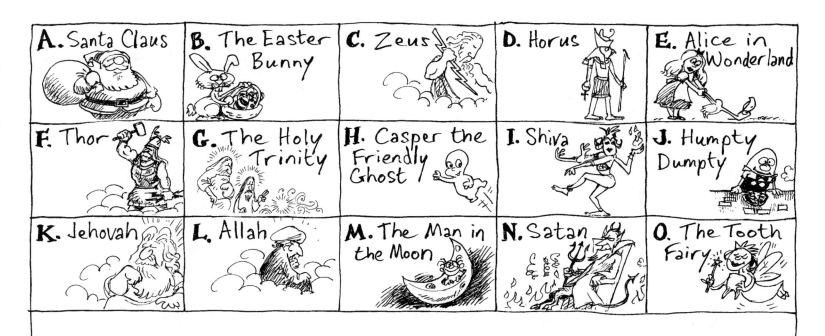

1. Can you provide **proof** of the existence of any of the above? (Photos please! — or at least documented scientific evidence).

2. That was a tough question, wasn't it! If you couldn't do it, don't worry — nobody else can either. Even so, you do know, don't you, that some people believe in some of them?

3. So... then can you — or anyone — explain why a newspaper columnist should have been fired for writing that people should be allowed to believe in (N.)?

COLUMNIST DEON MAAS →

P.S. SEND ANSWERS TO RAPPORT EDITOR TIM DU PLESSIS — NOT TO THIS CARTOONIST!

21·11·07 INDEP. NEWSPAPERS

ZAPIRO

21 November 2007

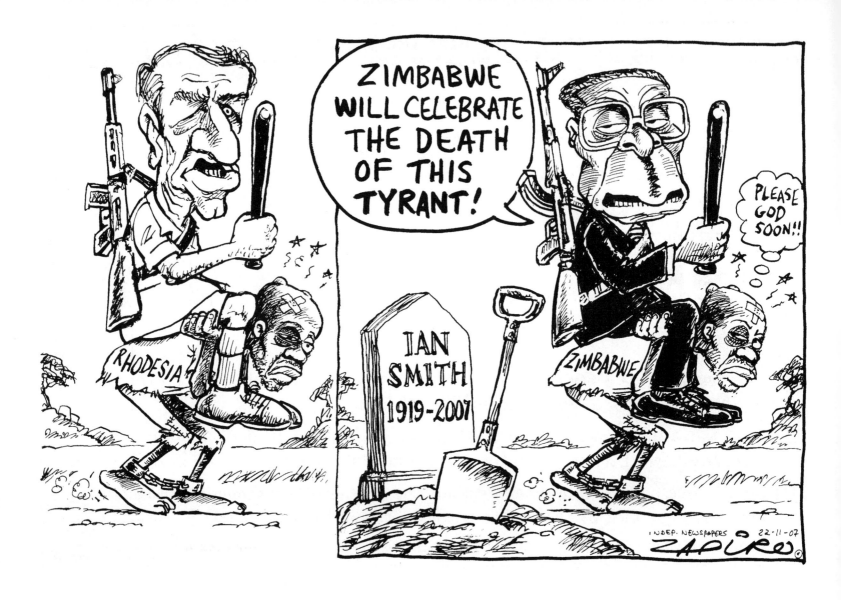

22 November 2007 Death of a former prime minister of white-minority-ruled Rhodesia

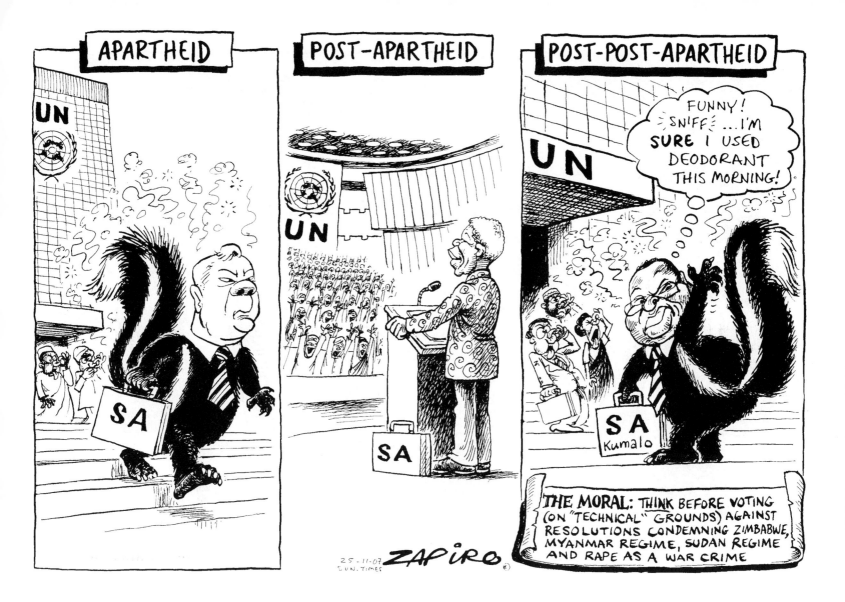

25 November 2007 Our record as a recent temporary member of the UN Security Council

39

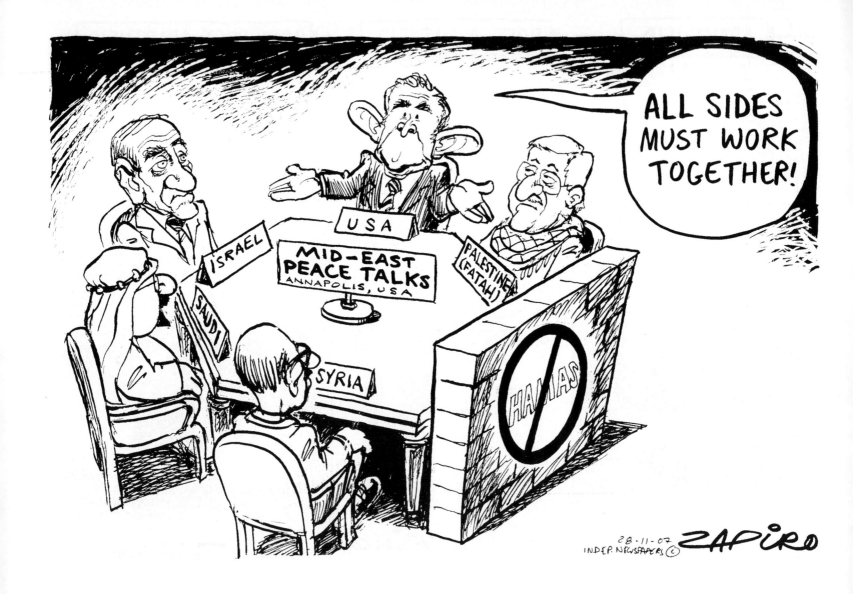

28 November 2007

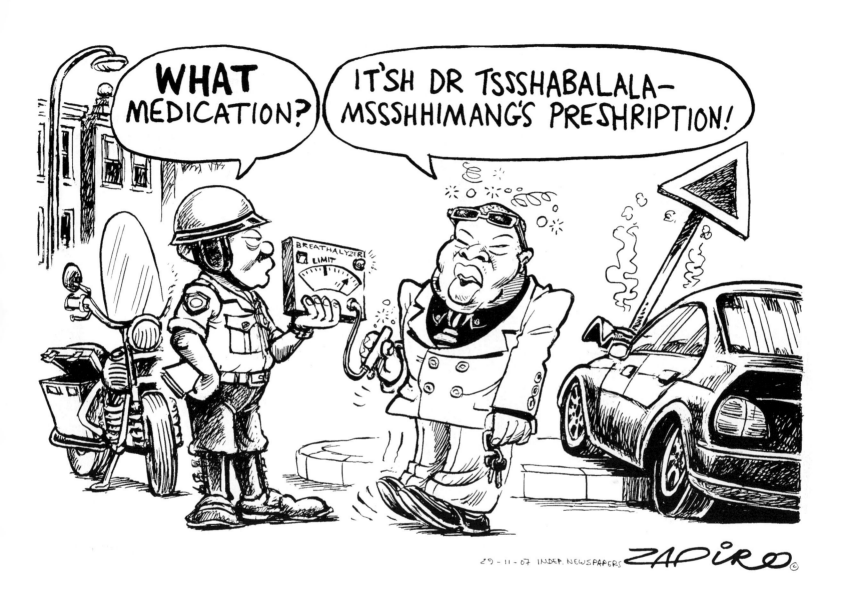

Ex-ANC chief whip Tony Yengeni prangs his BMW. Has he been drinking in breach of his parole condition? When tested positive for his drunk-driving, he says it was the flu medication.

29 November 2007

41

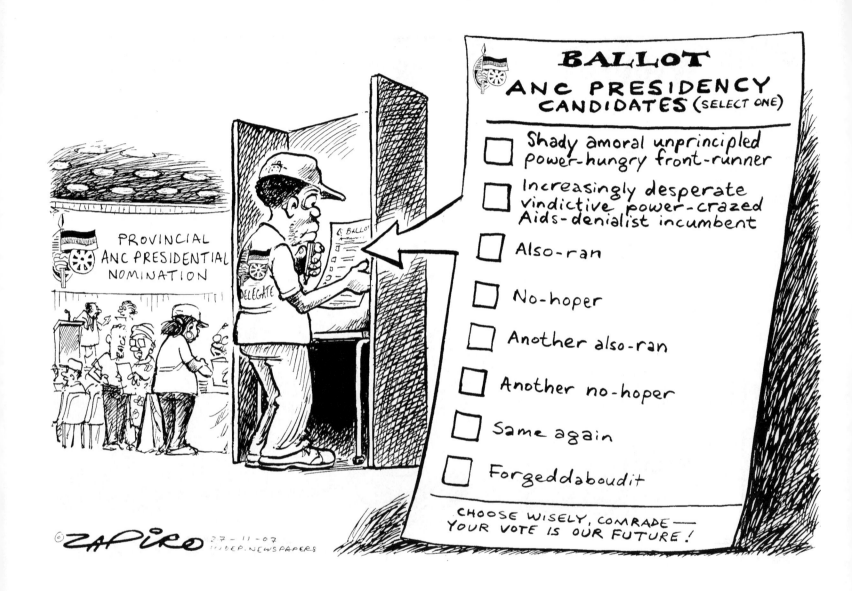

The ANC holds provincial conferences ahead
of next month's national conference at Polokwane

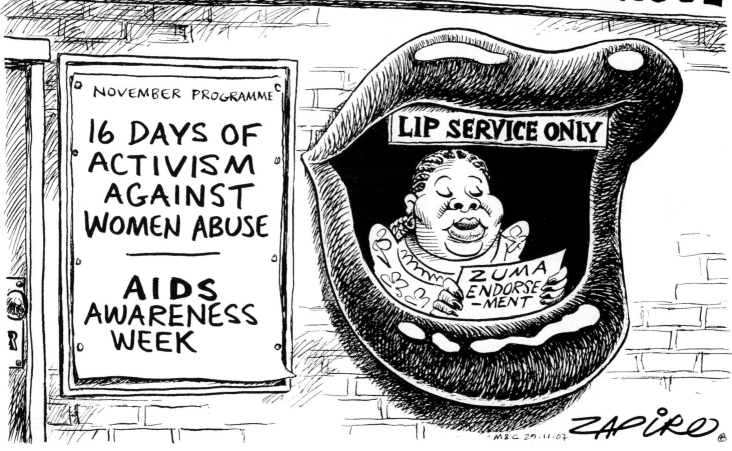

29 November 2007

ANCWL head Nosiviwe Mapisa-Nqakula announces that the league
will not be backing a woman for party president, but will back the
male polygamist who made misogynist statements during his rape trial

6 December 2007

At their conference, the endorsement is made official

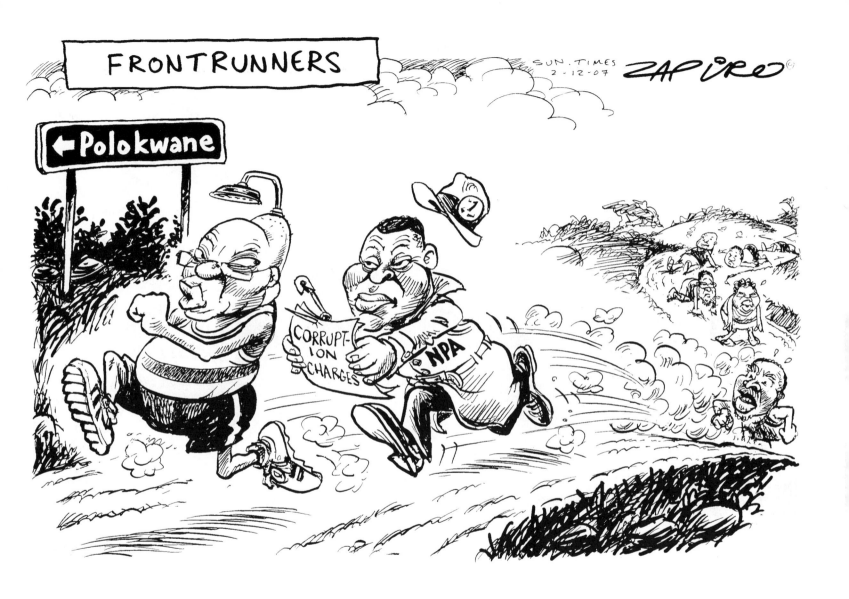

FRONTRUNNERS

←Polokwane

SUN.TIMES
2-12-07
ZAPIRO

CORRUPT-
ION
CHARGES

NPA

2 December 2007

Zuma has won the support of five out of nine provinces. Meanwhile
he's being shadowed by acting NPA head Advocate Mokotedi Mpshe.

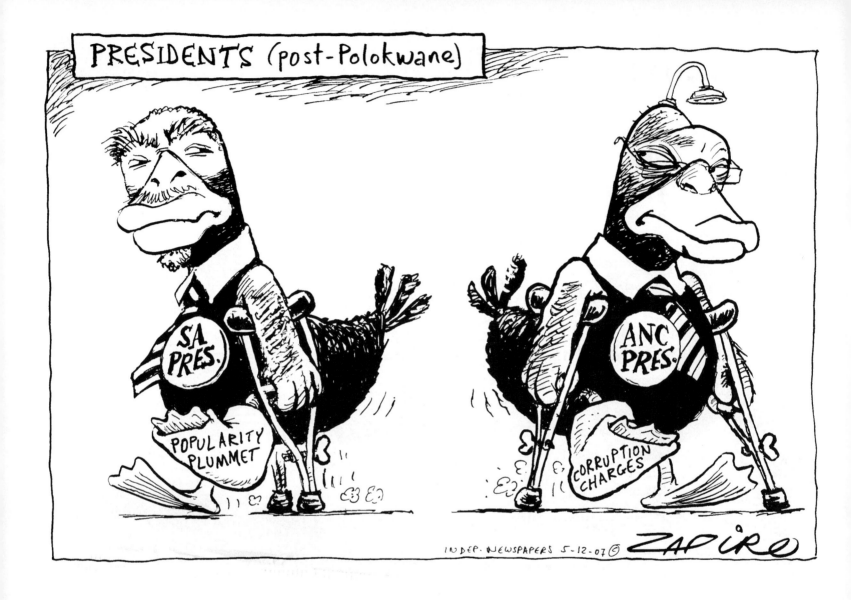

PRESIDENTS (post-Polokwane)

SA PRES.

POPULARITY PLUMMET

ANC PRES.

CORRUPTION CHARGES

INDEP. NEWSPAPERS 5-12-07 © ZAPIRO

A defiant Mbeki expects a surprise win.
With two weeks till the vote, here's a more likely outcome.

5 December 2007

46

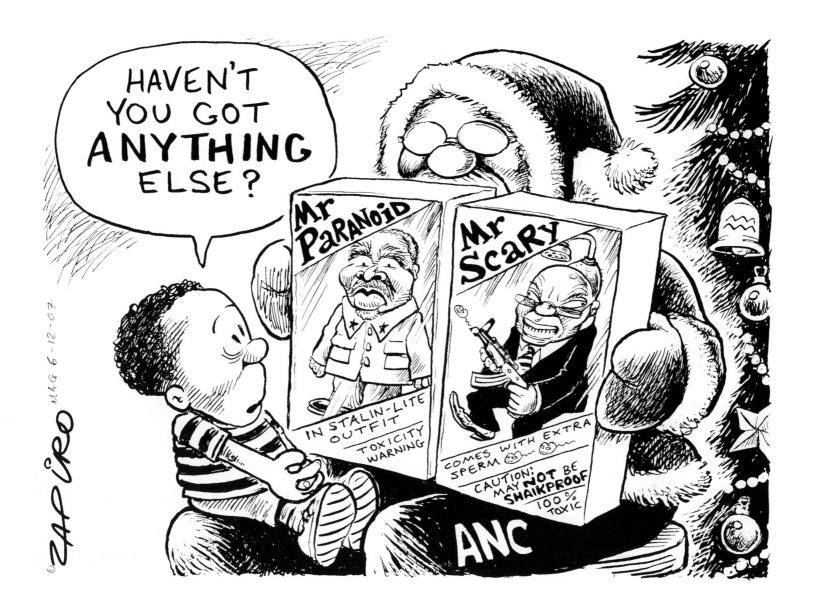

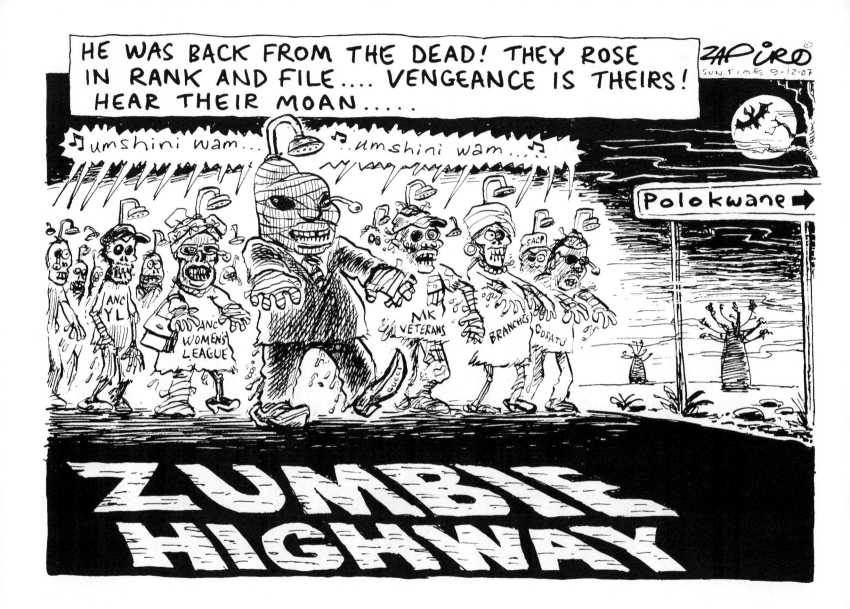

9 December 2007

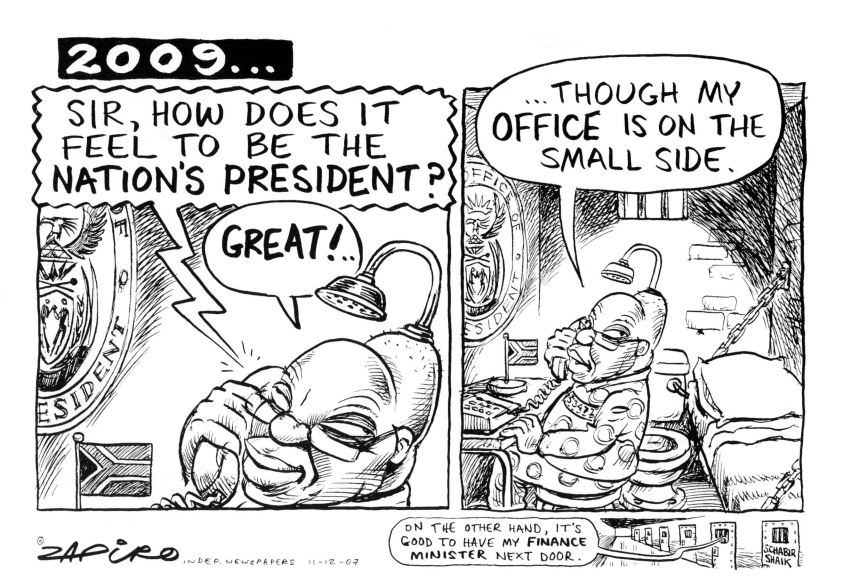

11 December 2007 If Zuma wins the ANC presidency as expected, he's set to move on to the top job

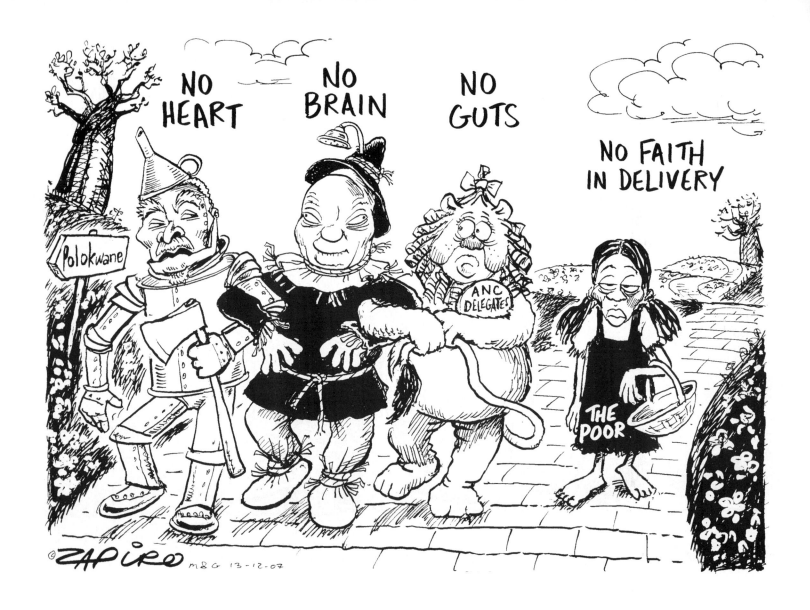

The ANC didn't stand up to Mbeki in his heyday.
Now some seem to support Zuma as the only way to get rid of Mbeki.

13 December 2007

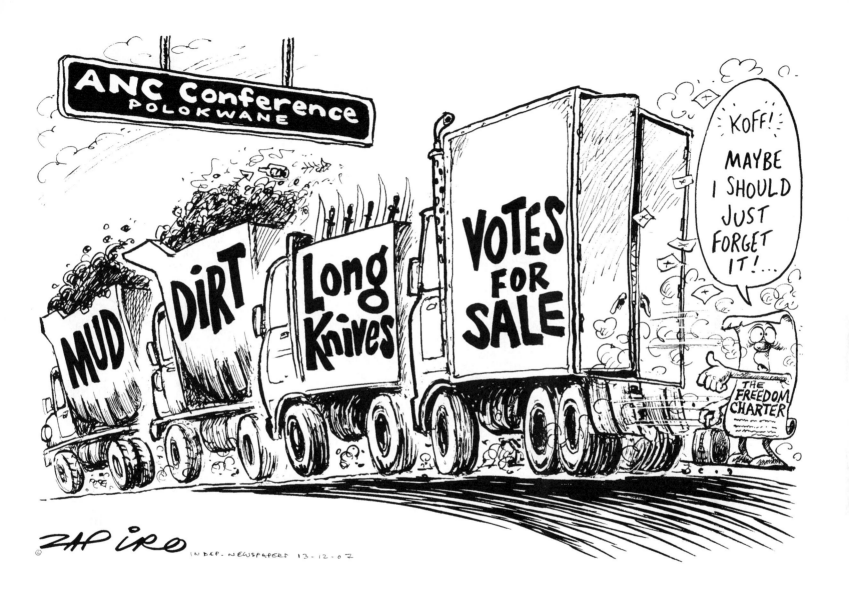

13 December 2007 — The worst factional acrimony in the party's history

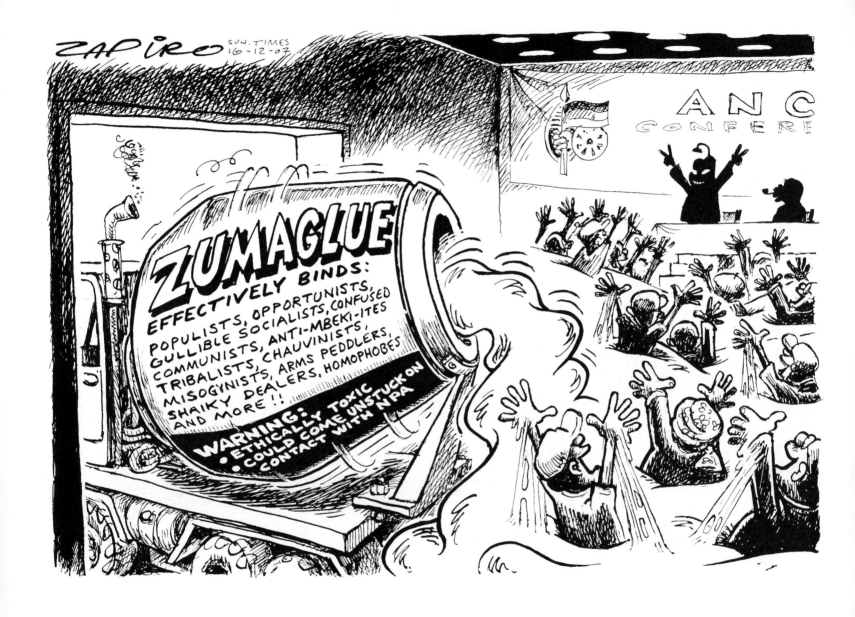

16 December 2007

The Zuma camp is rampant, heckling even
the most senior comrades seen to be Mbeki-ites

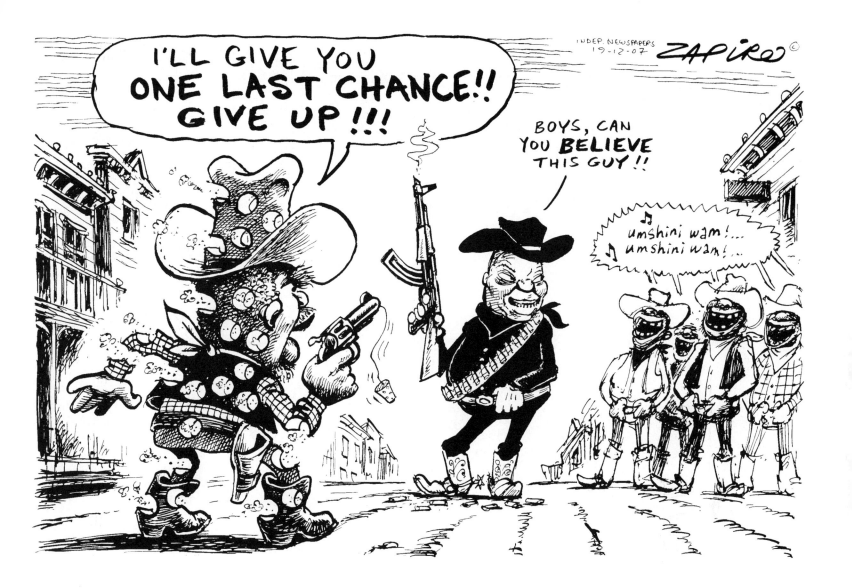

19 December 2007

Just before the vote, Mbeki lobbyists make a last
ditch attempt to secure him a third term as party leader

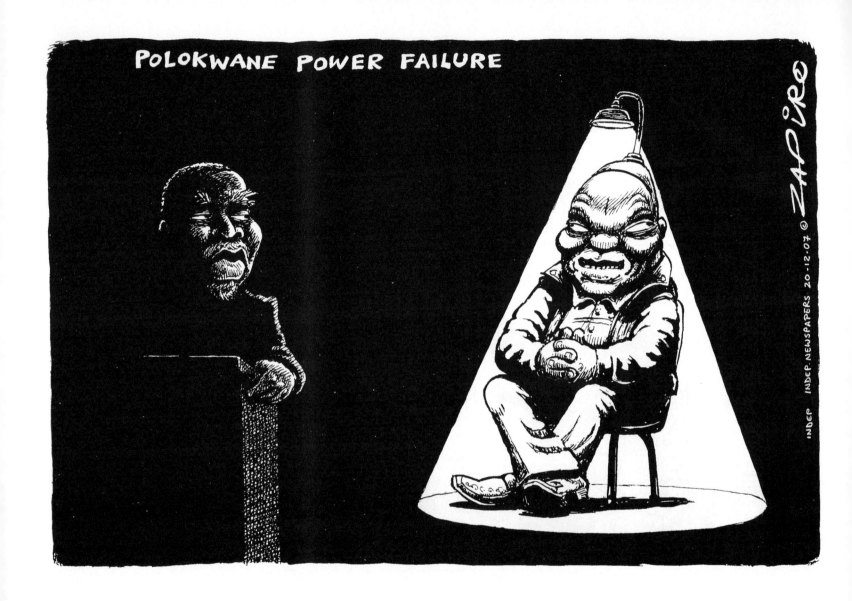

POLOKWANE POWER FAILURE

20 December 2007

Eskom's electricity crisis causes intermittent blackouts
as Zuma wins ANC leadership by a huge majority

54

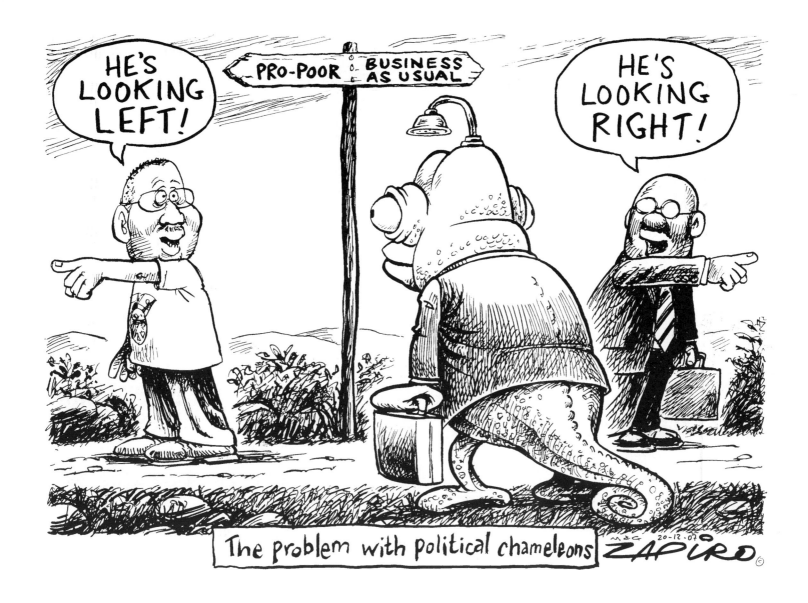

The problem with political chameleons

20 December 2007

Zuma's leftwing backers in Cosatu and the SACP now hear that
the new ANC leadership say there'll be no sharp policy shifts

55

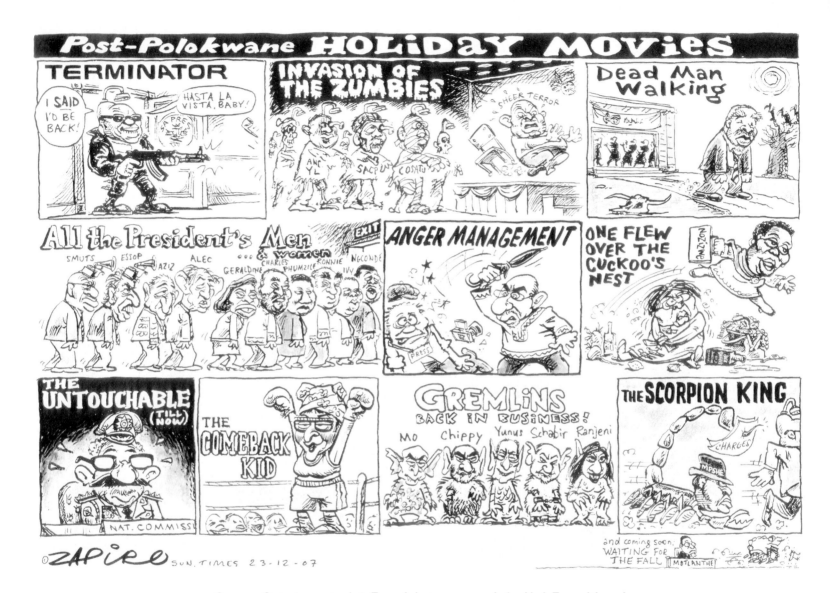

Cameos: Outgoing party chair Terror Lekota was severely heckled; Trevor Manuel
swatted a journalist with an umbrella; support for Manto plummeted as much
as it rose for her axed deputy, Nozizwe Madlala-Routledge; Winnie got many
voters; Kgalema Motlanthe became ANC deputy president.

23 December 2007

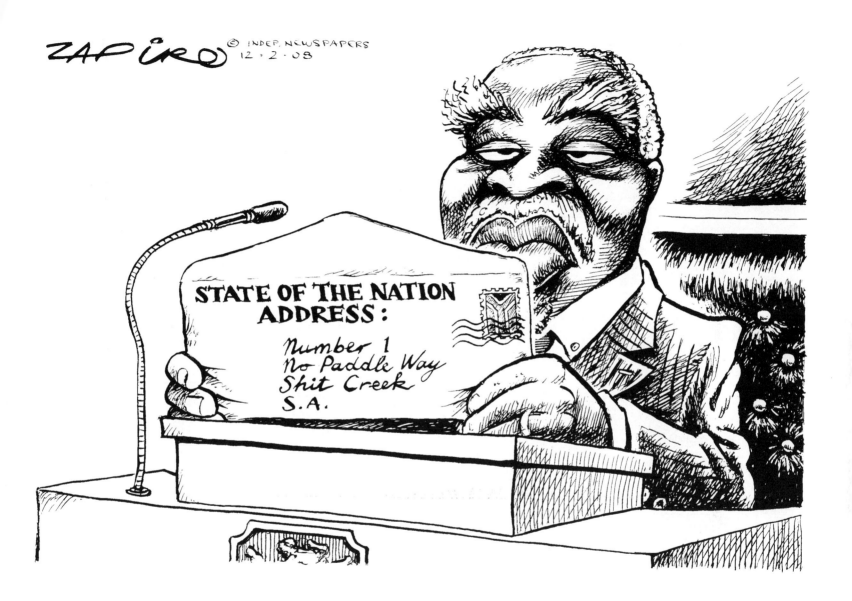

12 February 2008

He's still a president of the country, sort of. He's facing loss of support
in his own party, a crumbling legacy and much blame for the energy crisis.

57

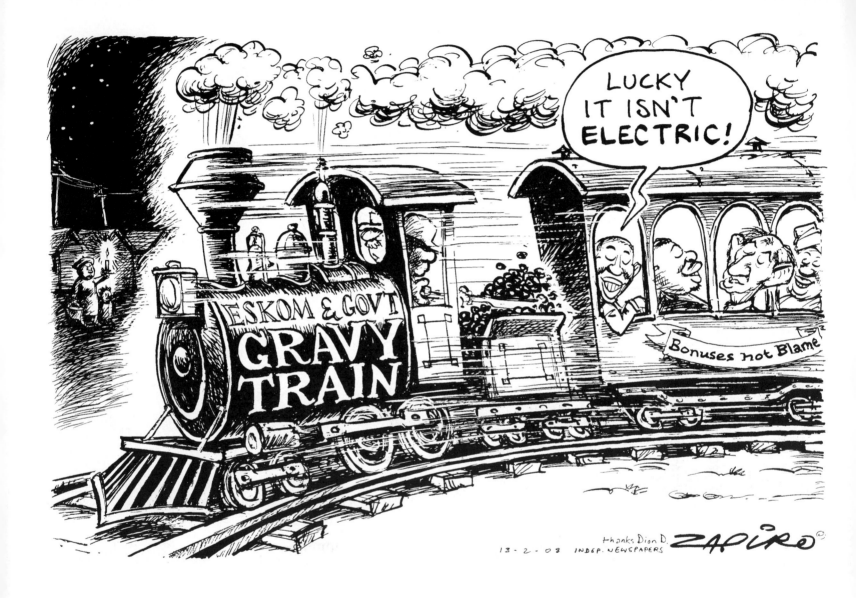

13 February 2008

As the abysmal failure of policy, capacity and maintenance leaves the country
in the dark, we hear that Eskom's top brass keep on receiving millions in bonuses

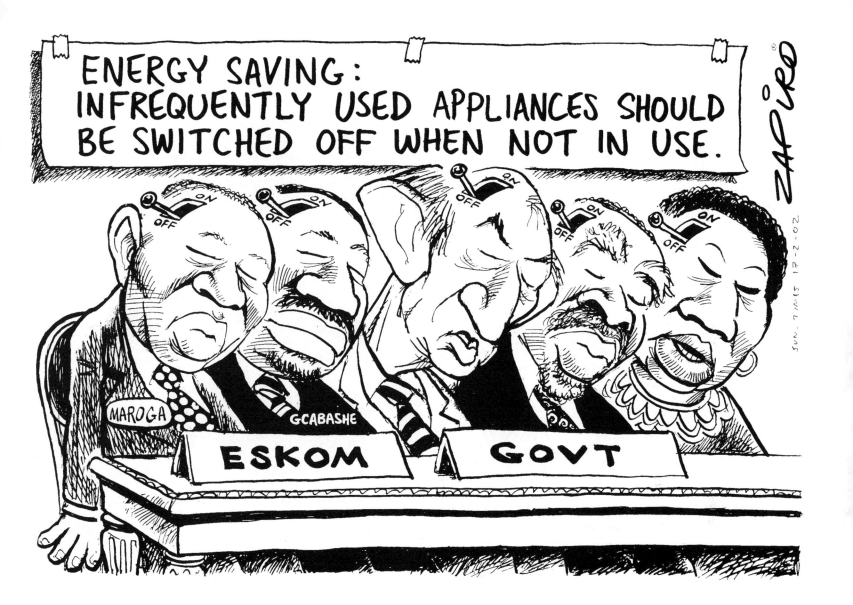

17 February 2008

There is no crisis, said government many years ago, as energy policy shortcomings were pointed out. Okay, *now* there's a crisis.

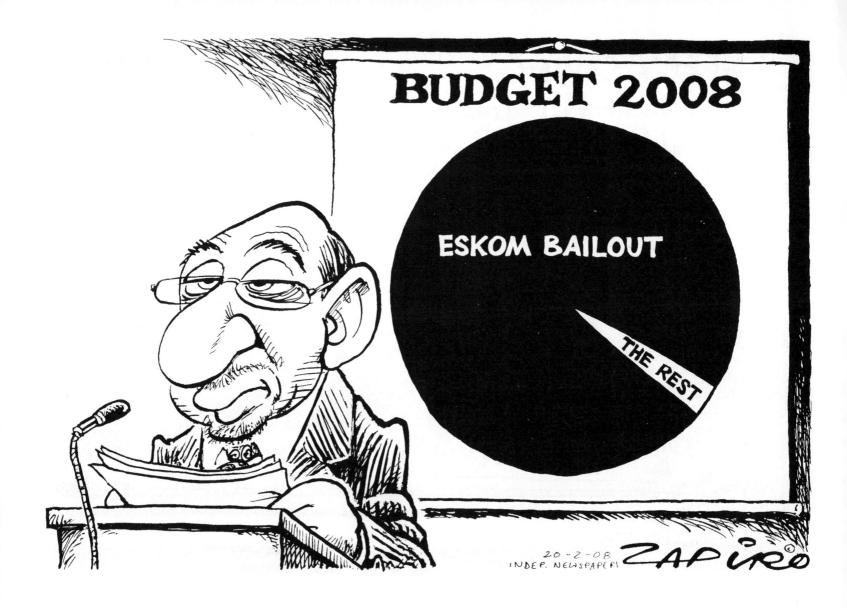

20 February 2008 Ahead of Budget Day, it's clear it'll be the taxpayer mopping up the mess

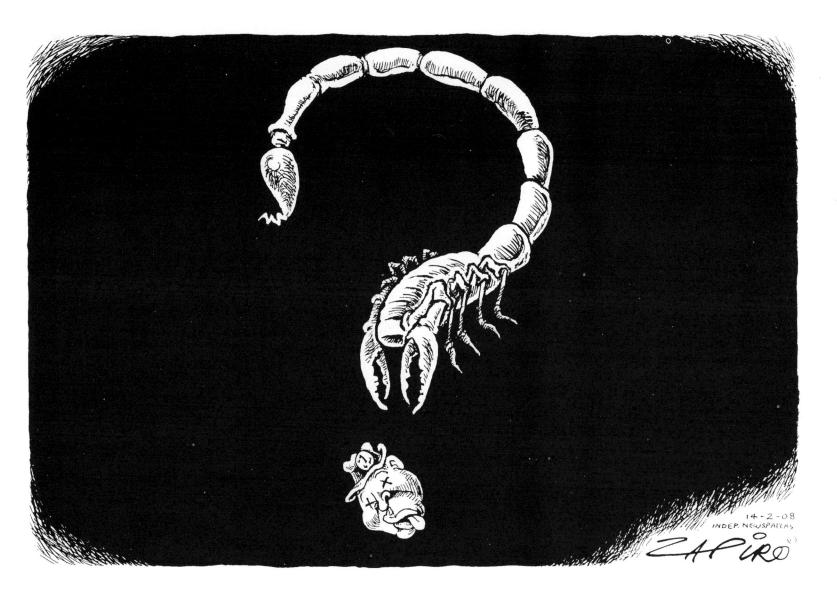

The ANC wants to disband the Directorate of Special Operations (the Scorpions).
It's because there should be a 'single police service', they say. It's got nothing
whatever to do with the Scorpions stinging ANC high-ups like Zuma.

14 February 2008

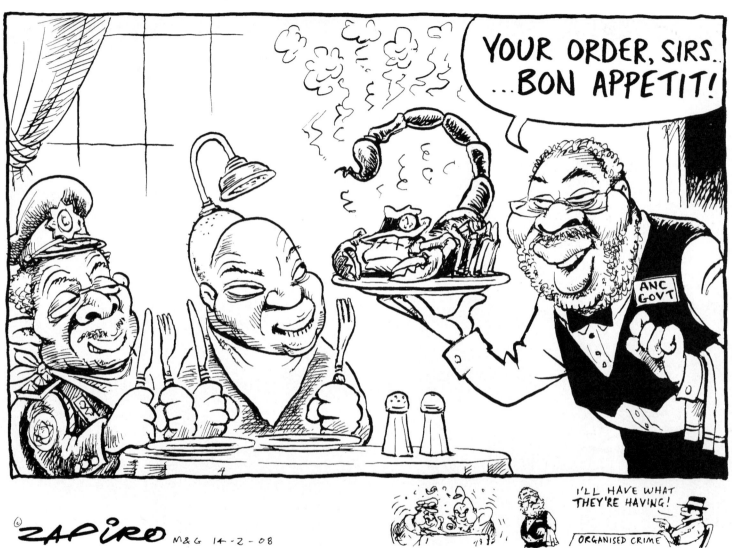

14 February 2008

The Safety and Security Minister confirms that
Cabinet has begun the process of disbanding the Scorpions

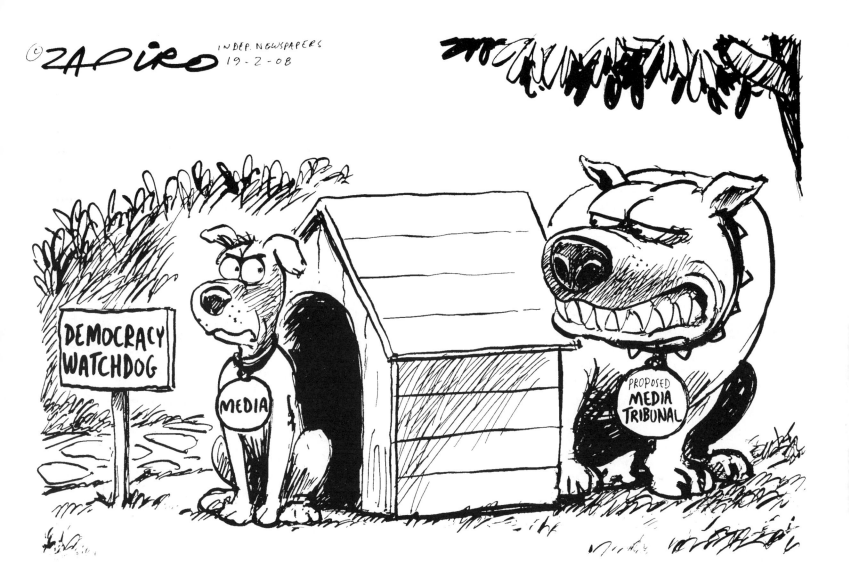

© ZAPIRO INDEP. NEWSPAPERS 19-2-08

DEMOCRACY WATCHDOG

MEDIA

PROPOSED MEDIA TRIBUNAL

19 February 2008

Civil society and the media groups warn that press freedom
will be threatened if the ANC-mooted media tribunal goes ahead

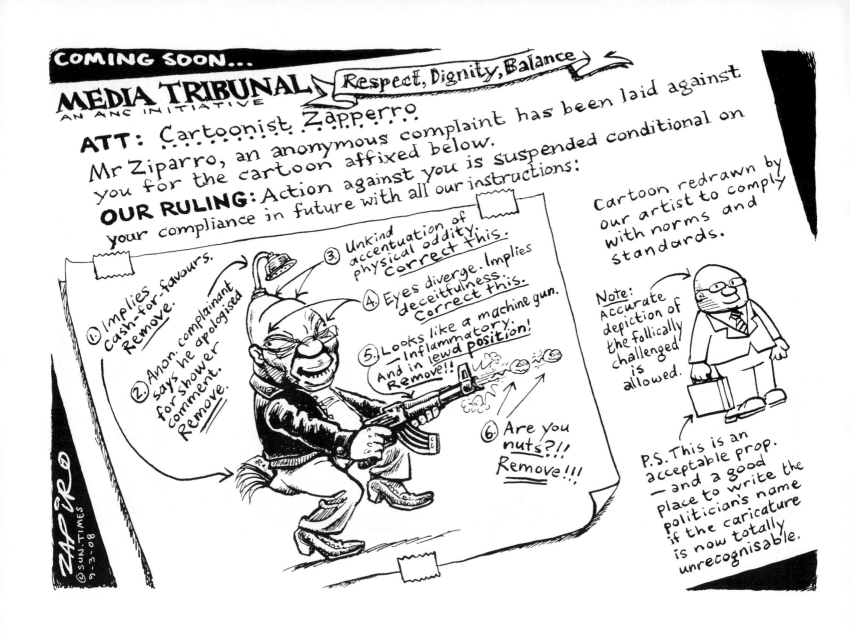

9 March 2008

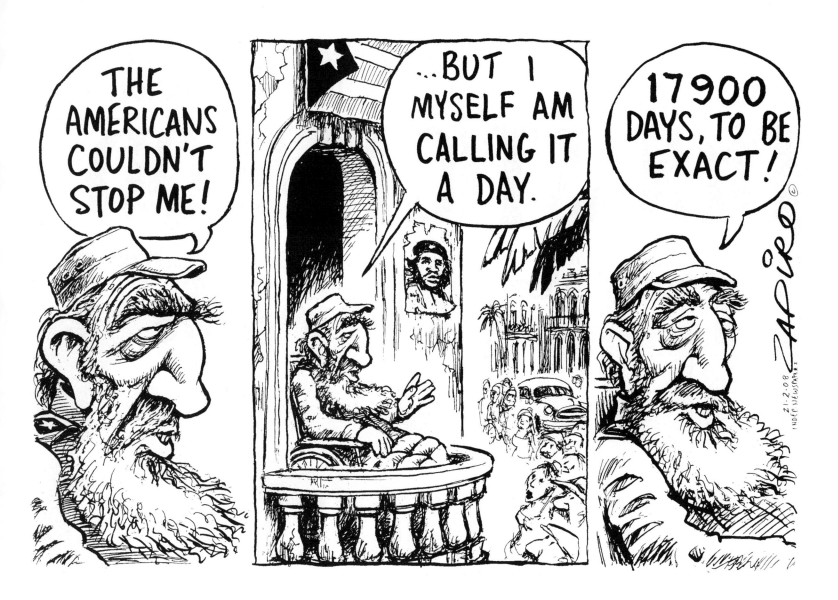

21 February 2008

Fidel Castro has been Cuba's president since 1959.
Ill health prompts his stepping down.

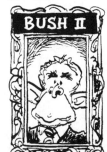

Hillary Clinton thought she had the US presidency sewn up until the
arrival of a younger challenger and fellow-Democrat, Senator Barack Obama

24 February 2008

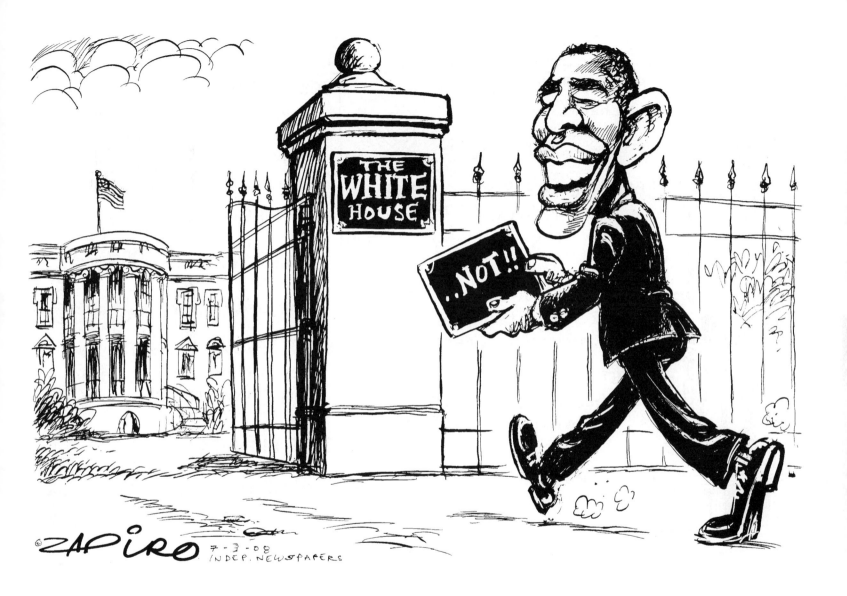

7 March 2008

He's the first black candidate who stands a real chance of going all the way

67

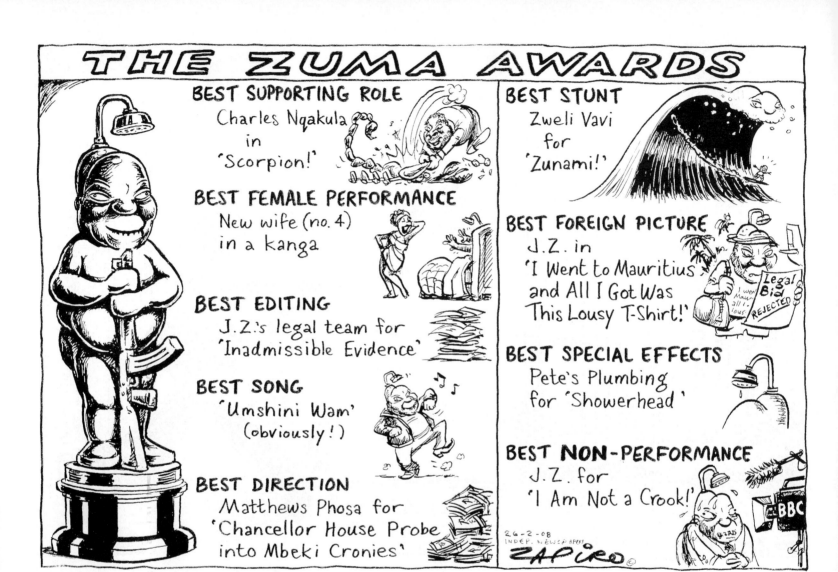

26 February 2008

27 February 2008 The Education Department proposes an oath of allegiance for school students to recite

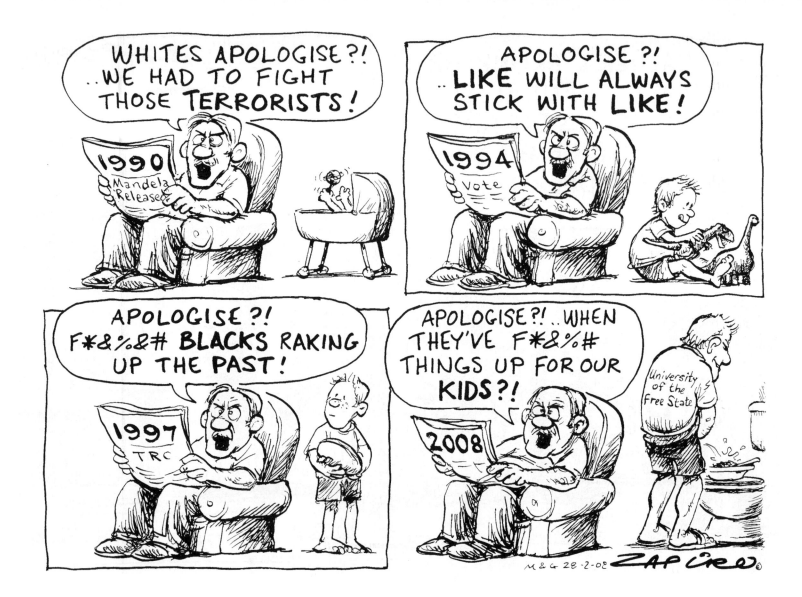

Shock at racist video made by University of the Free State students, in which they
are seen urinating on food later consumed by workers who are older black women

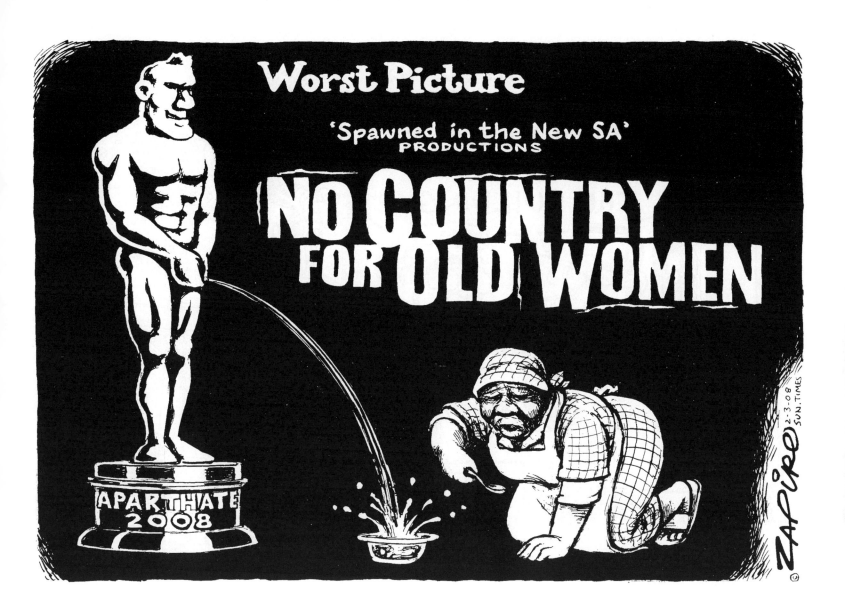

2 March 2008

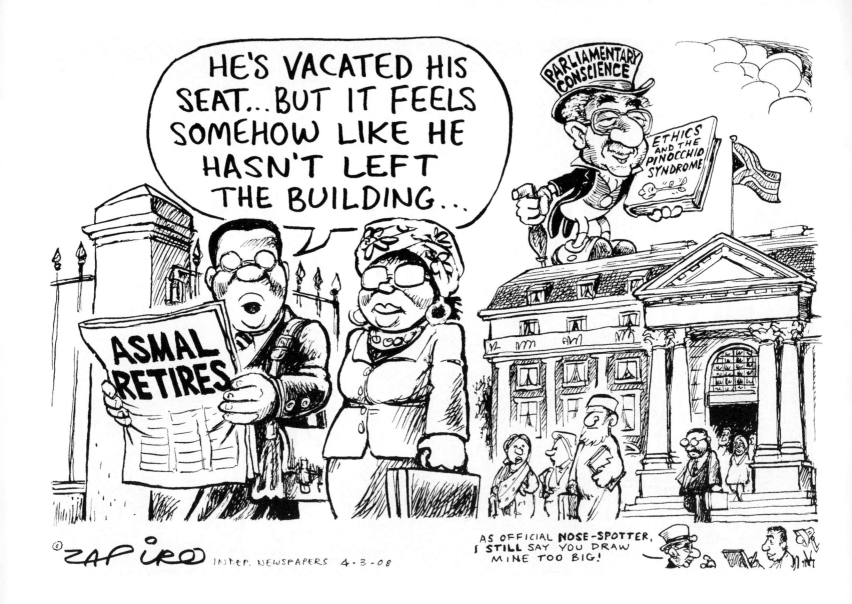

4 March 2008

Former minister Kader Asmal is retiring from parliament but
not from engaging in debate on democratic checks and balances

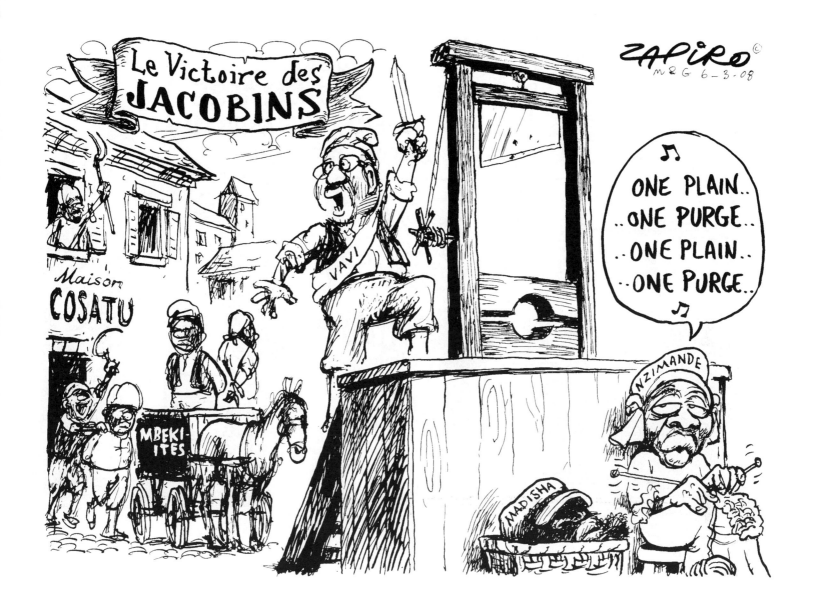

6 March 2008

Long-standing feud between the SACP's Blade Nzimande and unionist
Willie Madisha over missing funds ends with Madisha's expulsion from Cosatu

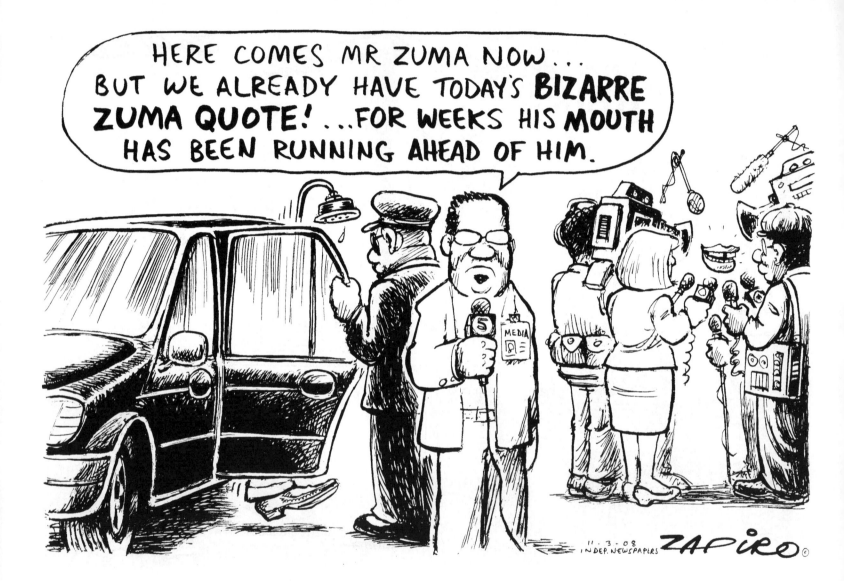

11 March 2008

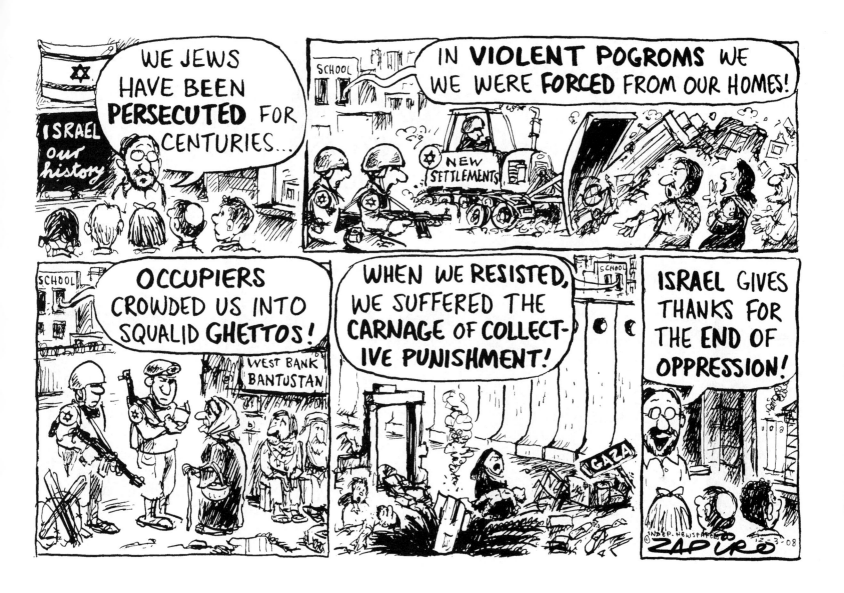

New settlements with military backing are going ahead on occupied land

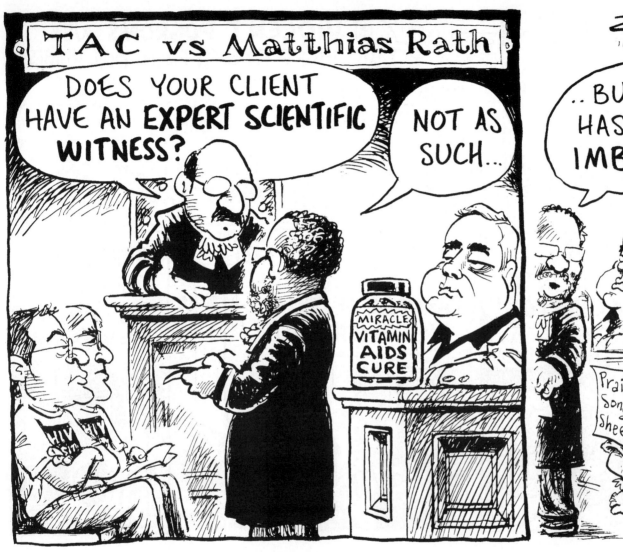

The Treatment Action Campaign's quack opponent
has for ages had the Health Department's tacit support

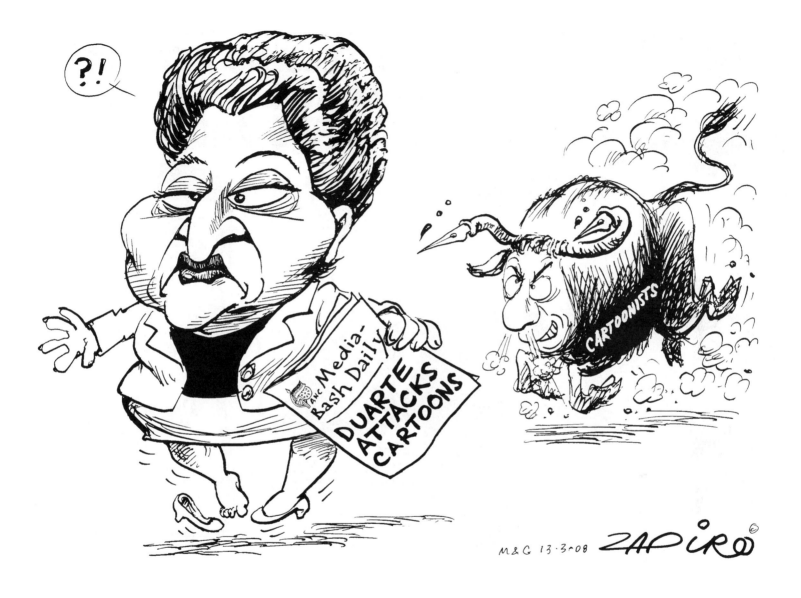

13 March 2008

ANC communication head Jessie Duarte suffers a sense of humour failure and
complains about the fate of a cartoon character (Eve Sisulu in *Madam & Eve*)

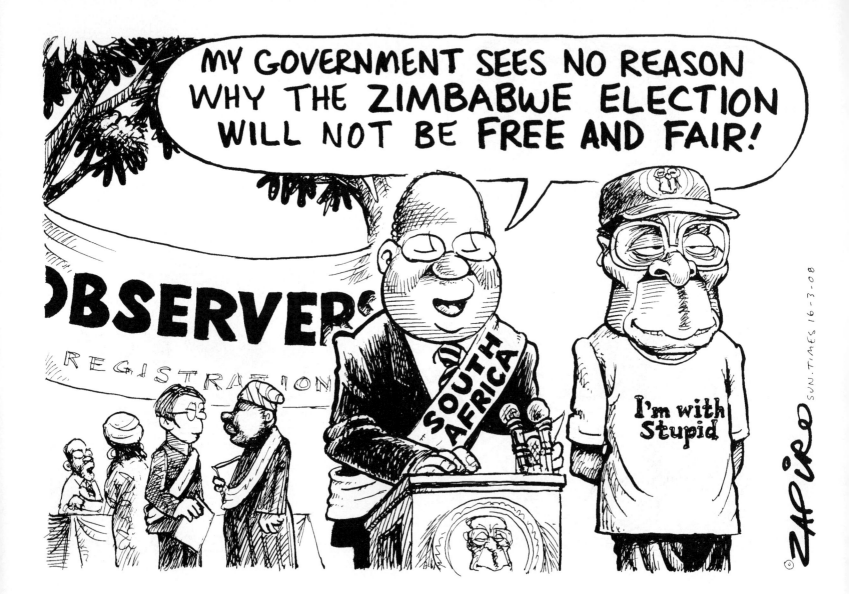

16 March 2008 With two weeks to go, President Mbeki's message is conveyed

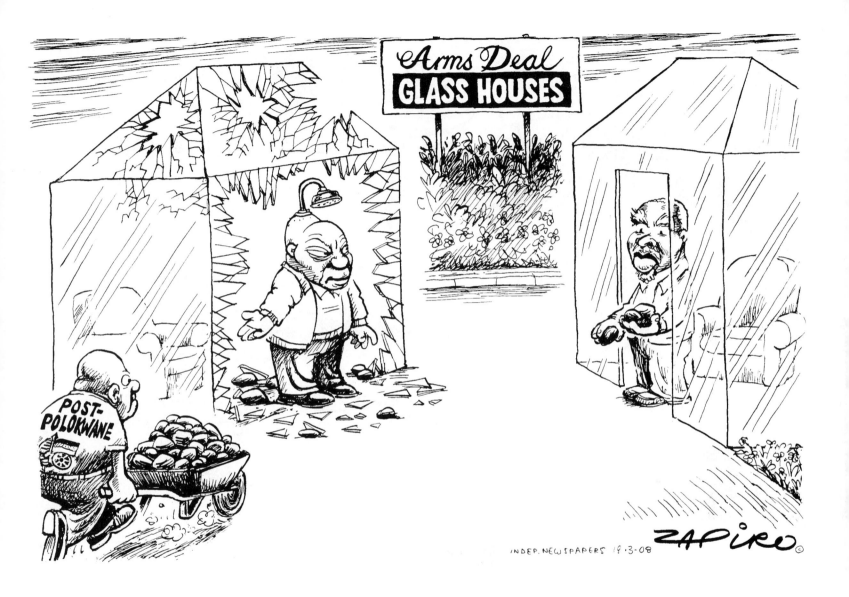

19 March 2008

Digging the dirt on Mbeki's role in the arms deal, the Zuma camp
aims to force a general amnesty for anyone implicated in corruption

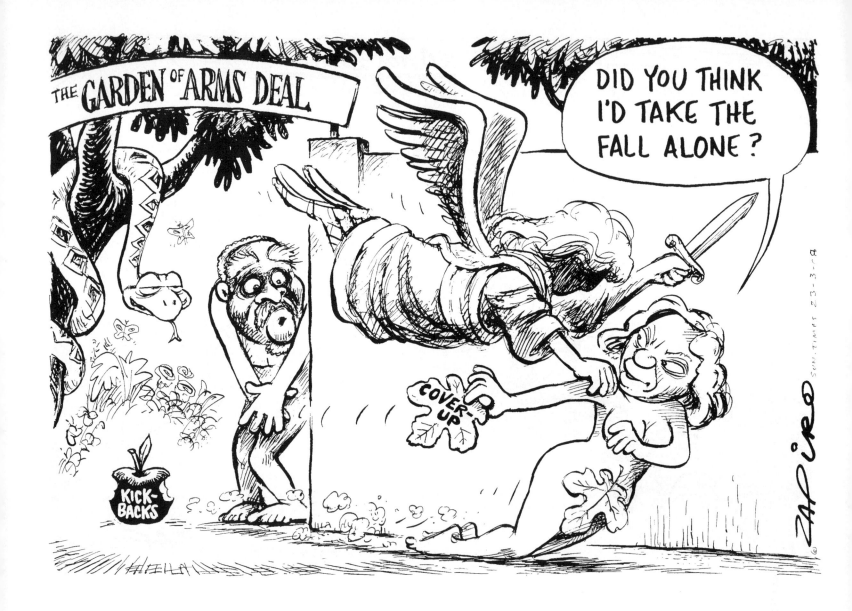

23 March 2008

Zuma threatens that unless there's a general amnesty, he'll force
Mbeki into the witness box in his own upcoming corruption trial

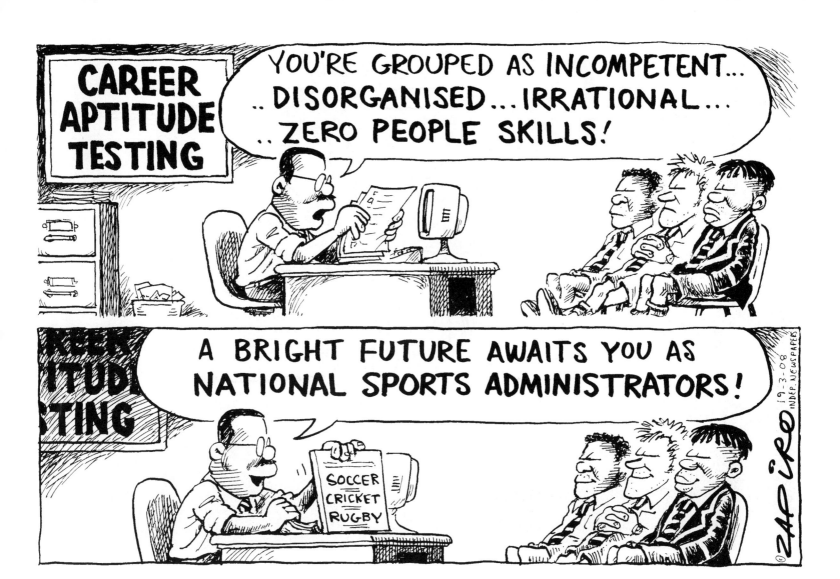

19 March 2008 Lurching from one off-field crisis to another

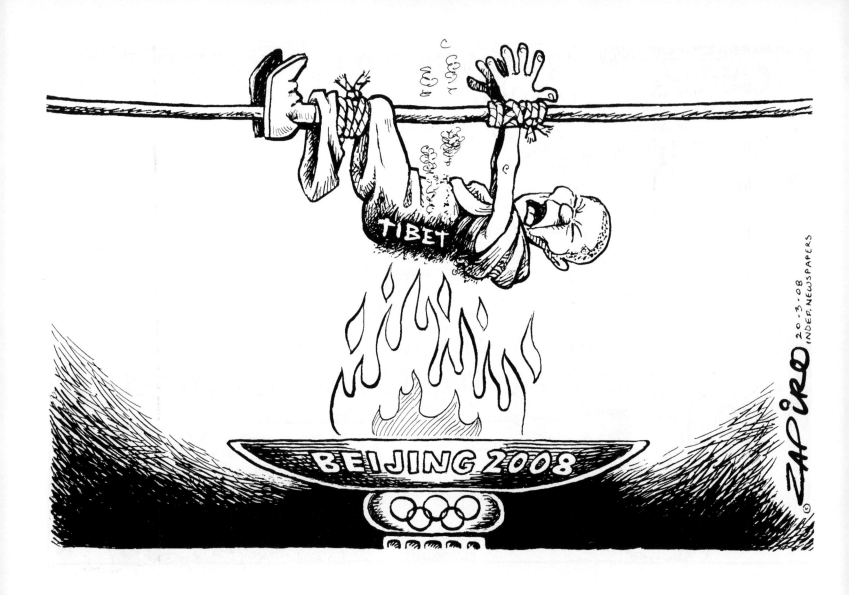

20 March 2008

Months before the Olympics, scores of protesters are killed by Chinese security forces in Lhasa, Tibet, when Buddhist monks lead marches against Chinese occupation

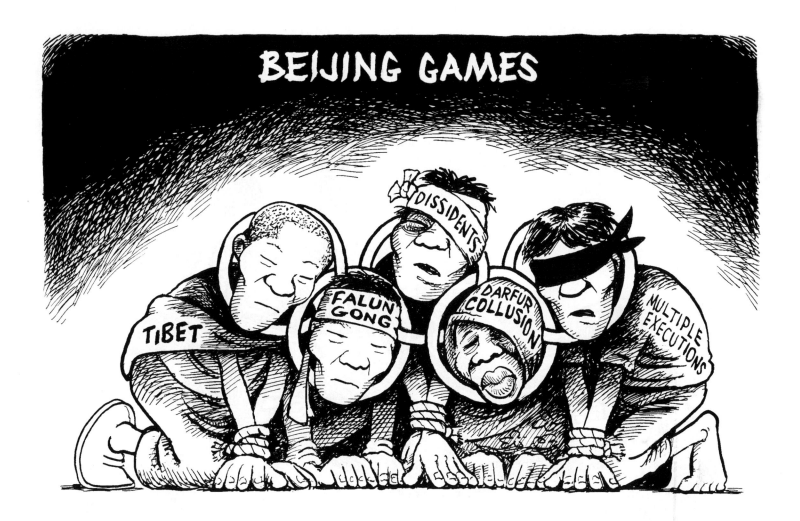

20 March 2008

Human rights campaigners urge China to uphold Olympic
ideals by pressing its ally Sudan to stop atrocities in Darfur

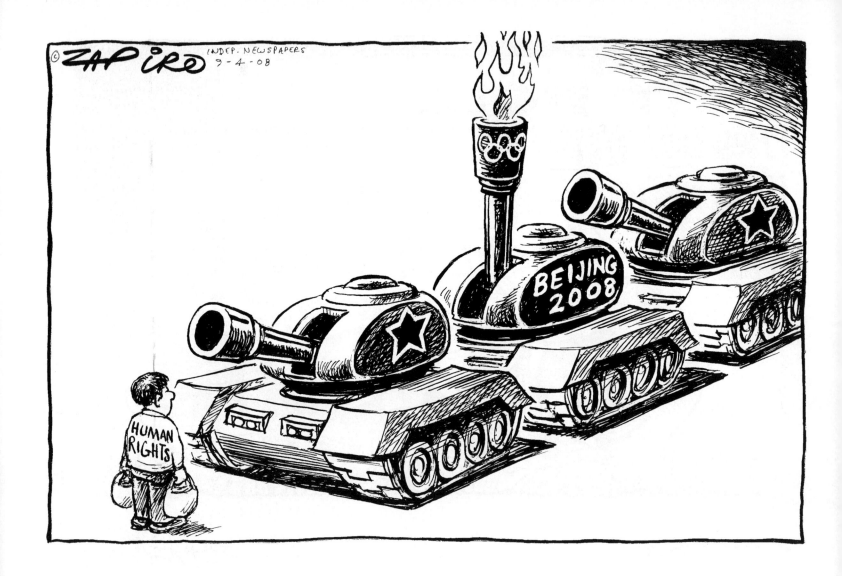

9 April 2008

Protests dog the cross-continental Olympic torch relay

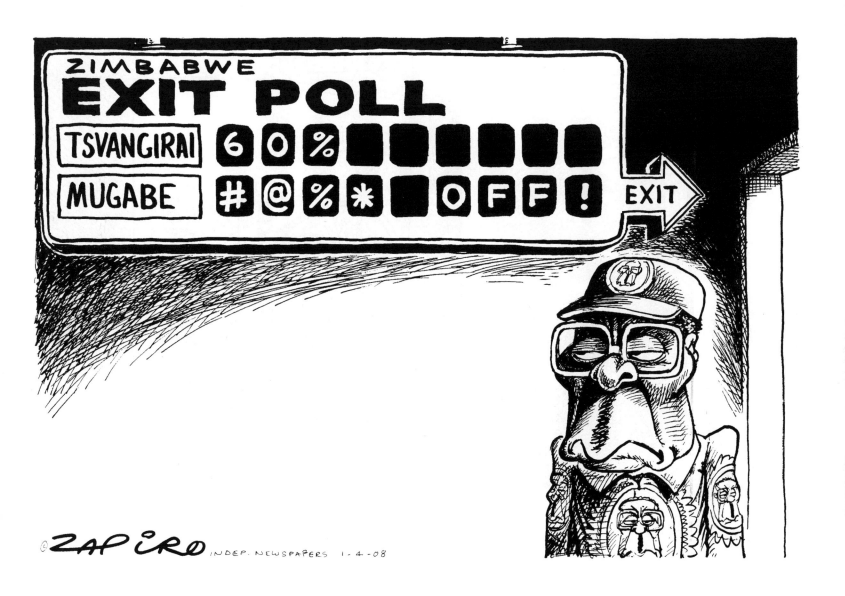

1 April 2008

Three days after the general election, unofficial tallies have the opposition MDC
just ahead, with its leader Morgan Tsvangirai way ahead in the presidential vote

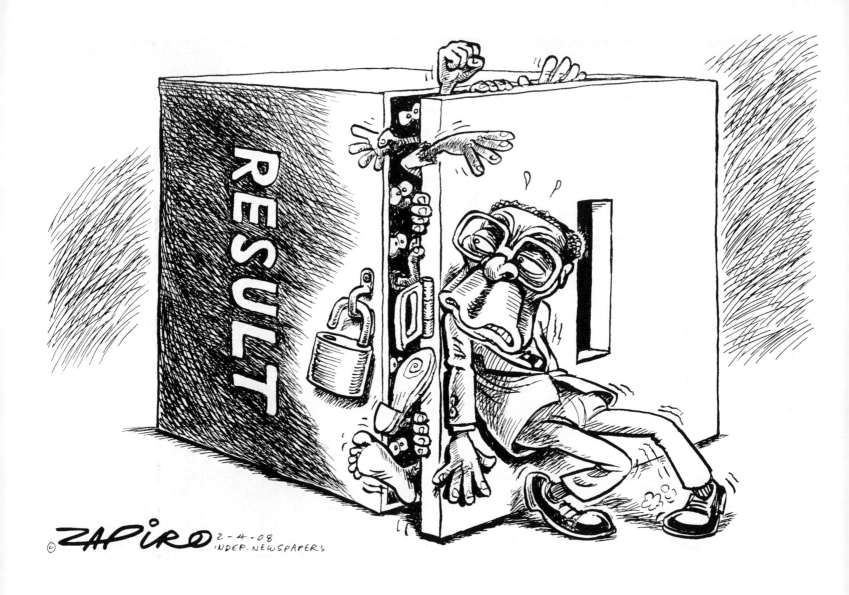

2 April 2008

After four days, the electoral commission says it's still counting,
but word is Mugabe's holding back the result to manipulate it

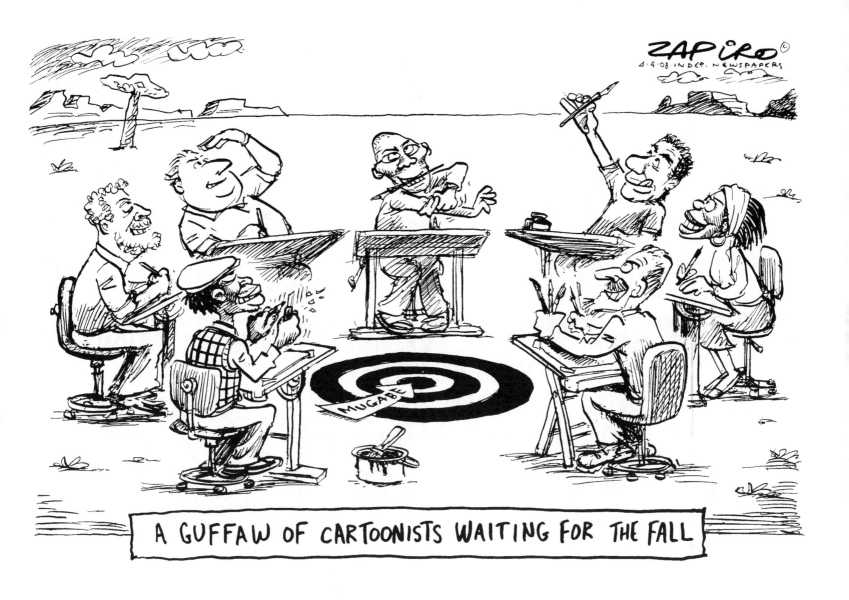

A GUFFAW OF CARTOONISTS WAITING FOR THE FALL

After five days, the old despot may be facing defeat, with the loyalty of
his armed forces no longer certain. He's even rumoured to be heading for exile.

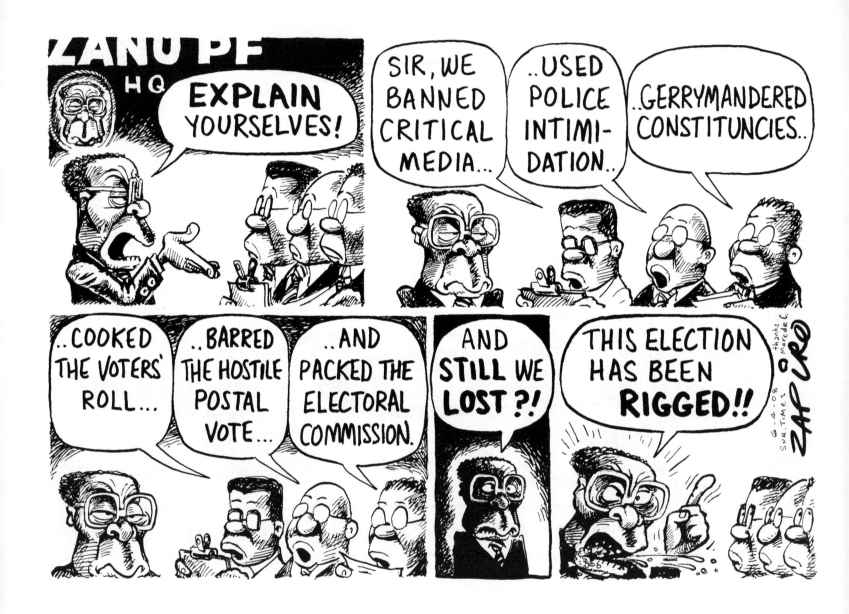

6 April 2008

Eighth day. The MDC has gone to court to force the
release of the presidential vote result. Zanu wants a recount.

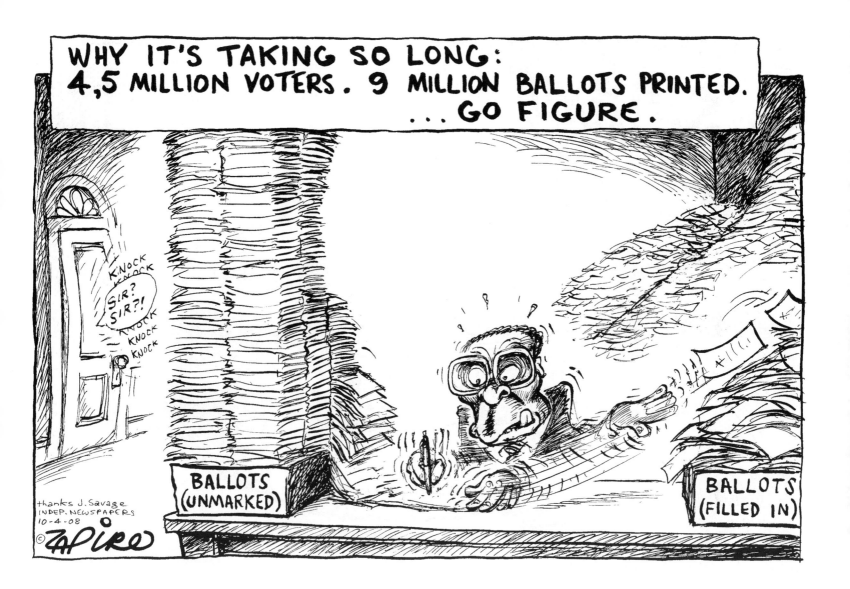

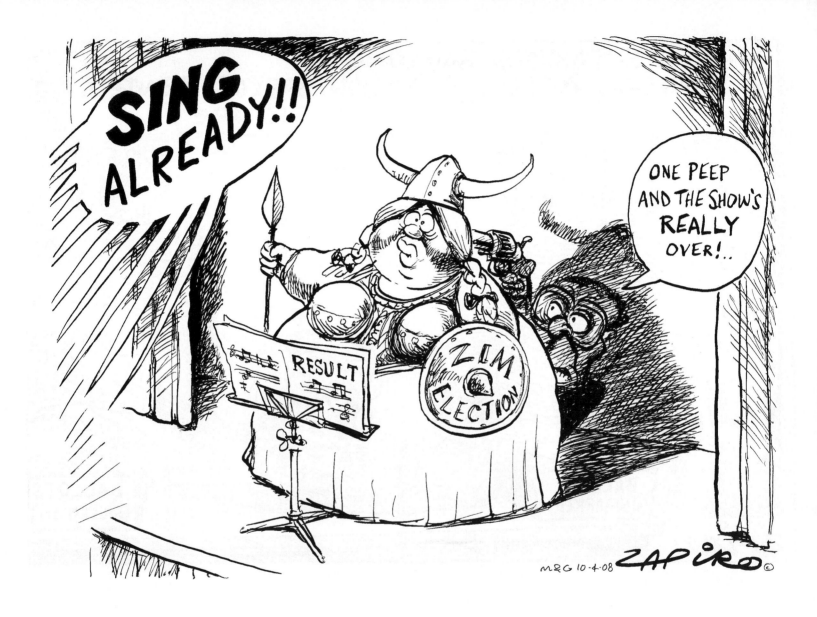

10 April 2008

Still no word from the electoral commission, yet there's talk
of a run-off vote. Zanu-PF militias terrorise opposition supporters.

90

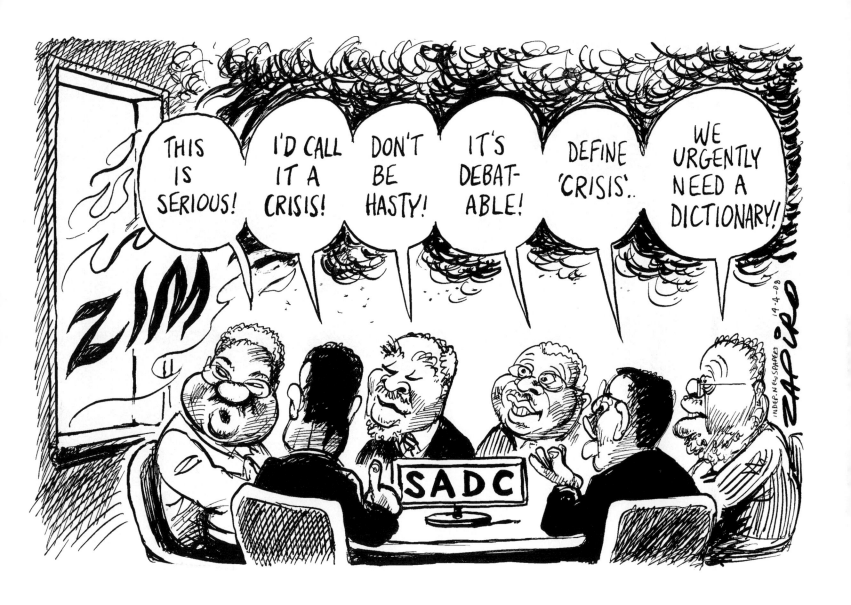

14 April 2008

Concerned regional leaders meet in Zambia to discuss the Zimbabwe impasse. 'There's no crisis', says Mbeki, fresh from talks with Mugabe.

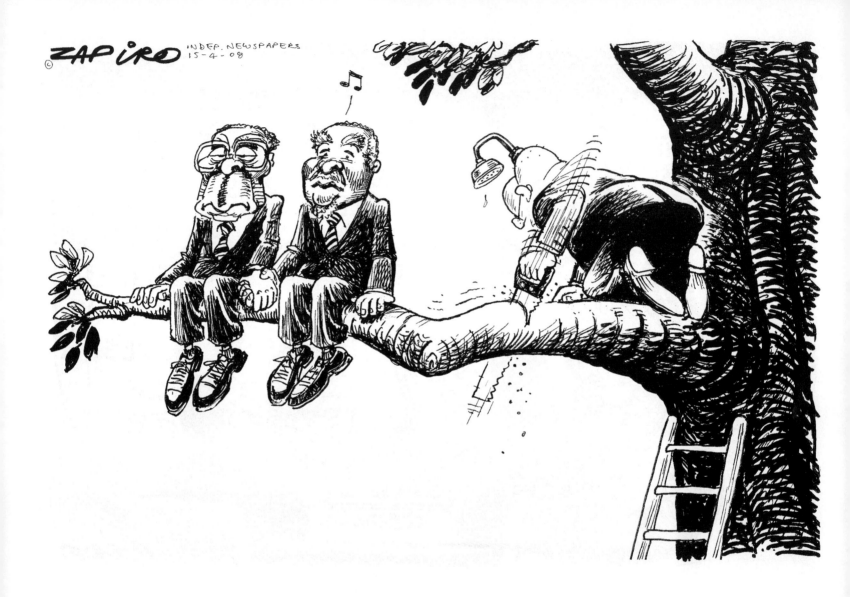

15 April 2008

Breaking ranks with Mbeki, the ANC president
sharply criticises the non-release of the election result

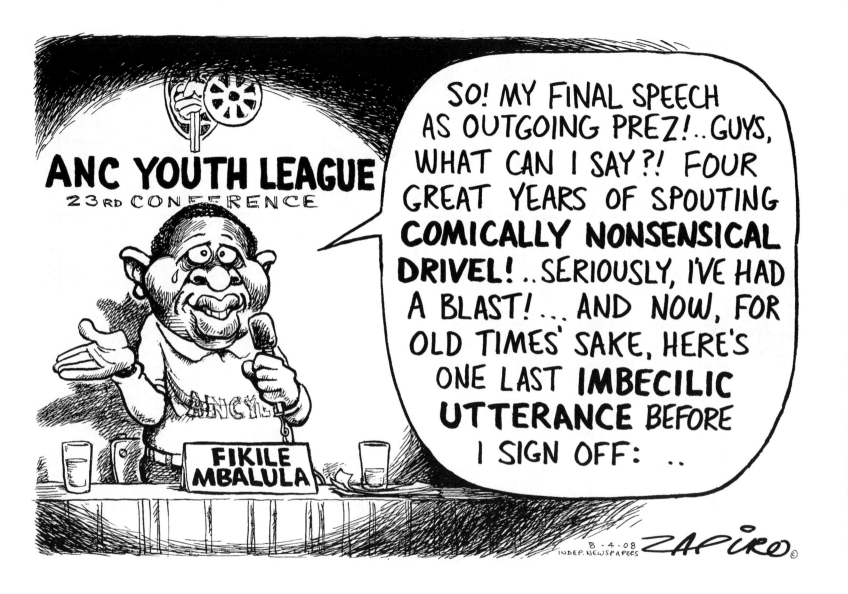

8 April 2008

The Youth League president known for his
bizarre attacks on Zuma's critics is stepping down

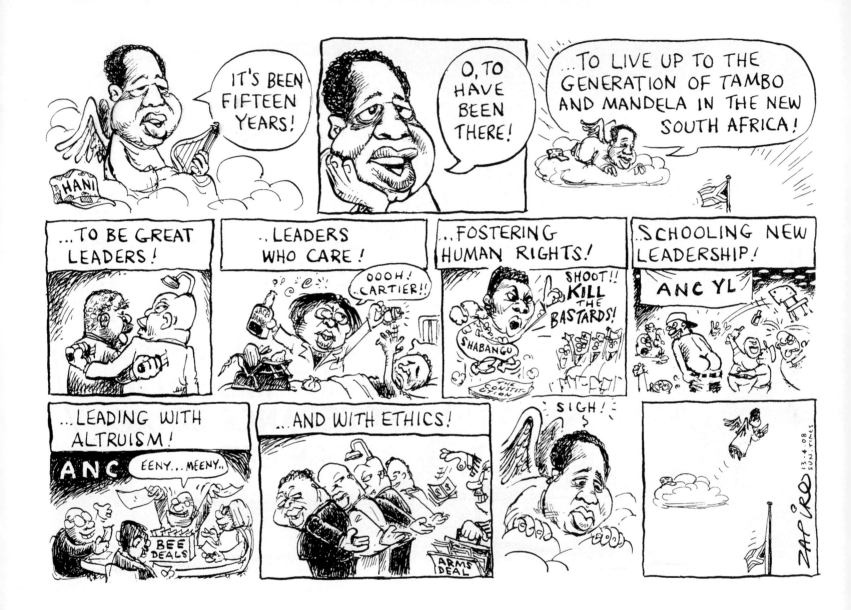

13 April 2008

Anniversary of the assassination of Chris Hani in 1993

22 May 2008

Xenophobic violence breaks out in Gauteng and spreads
across the country. 60 people are killed and 60,000 made homeless.

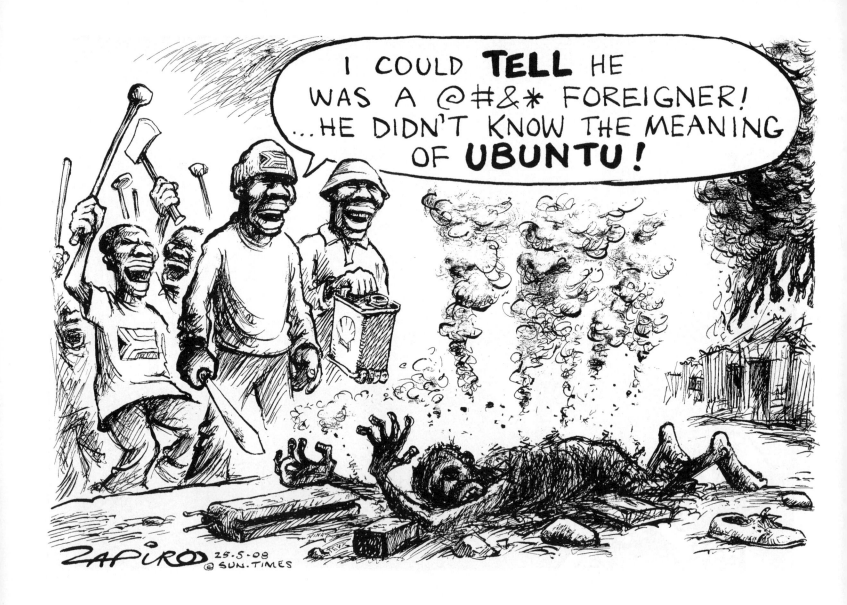

Shocking image beamed worldwide of a Mozambican burning to death.
Marauding mobs used crude 'language tests' to identify supposed foreigners.

25 May 2008

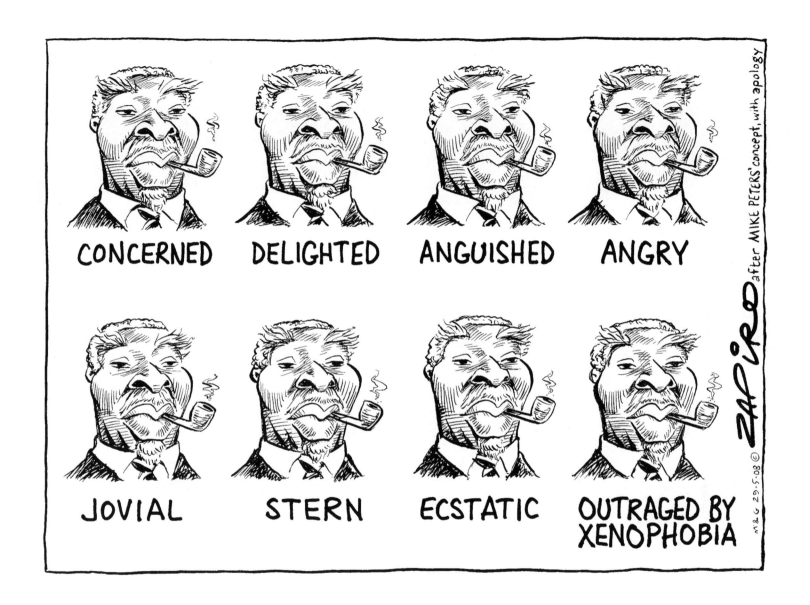

More than two weeks of carnage draws little response from the President.
At least, characteristically muted, he makes a televised condemnation.

29 May 2008

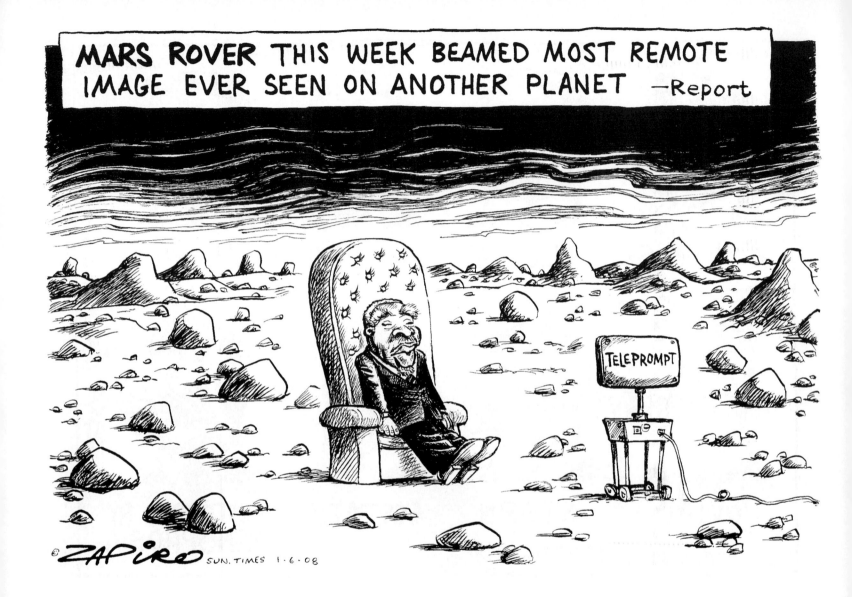

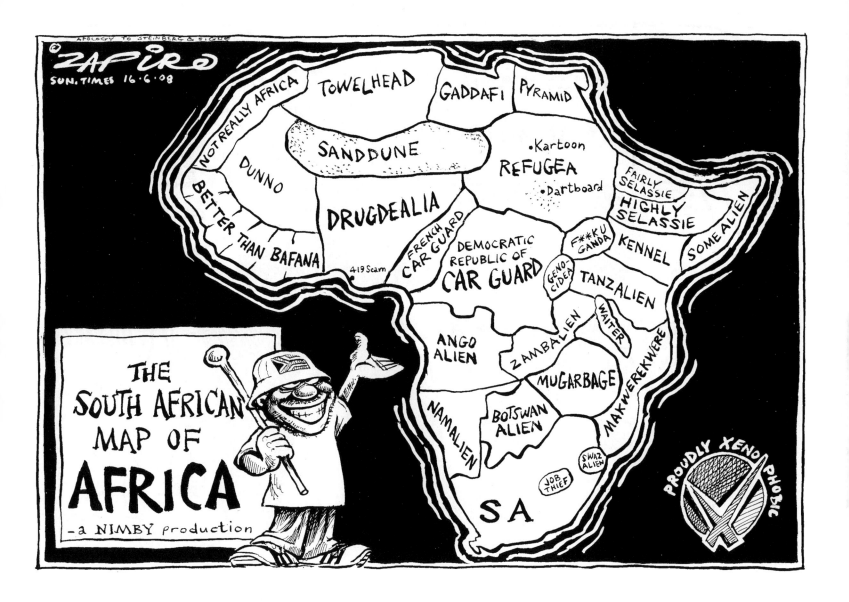

16 June 2008

While government blames the attacks on some 'third force',
the rest of us see a clearer connection to our national prejudices

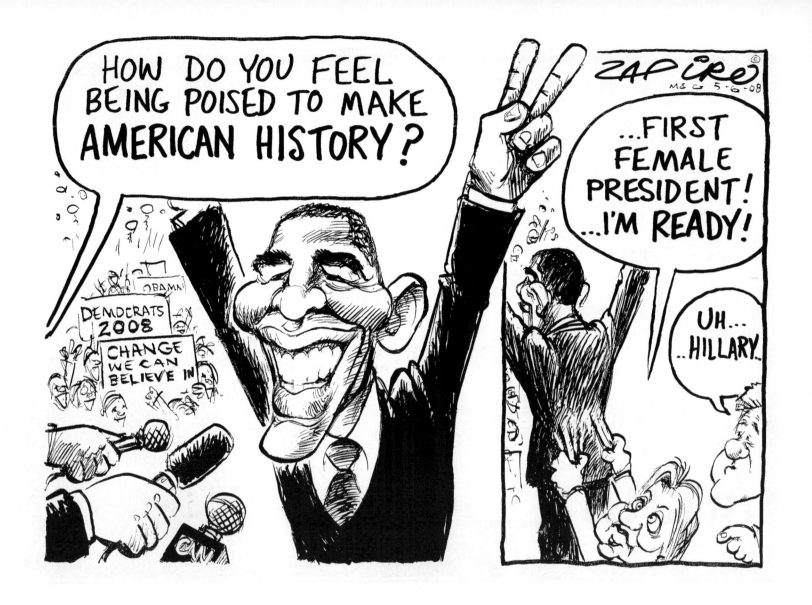

5 June 2008

Senator Barack Obama is the first black candidate to win a presidential
nomination, but rival Democrat Hillary Clinton is still not willing to concede defeat

100

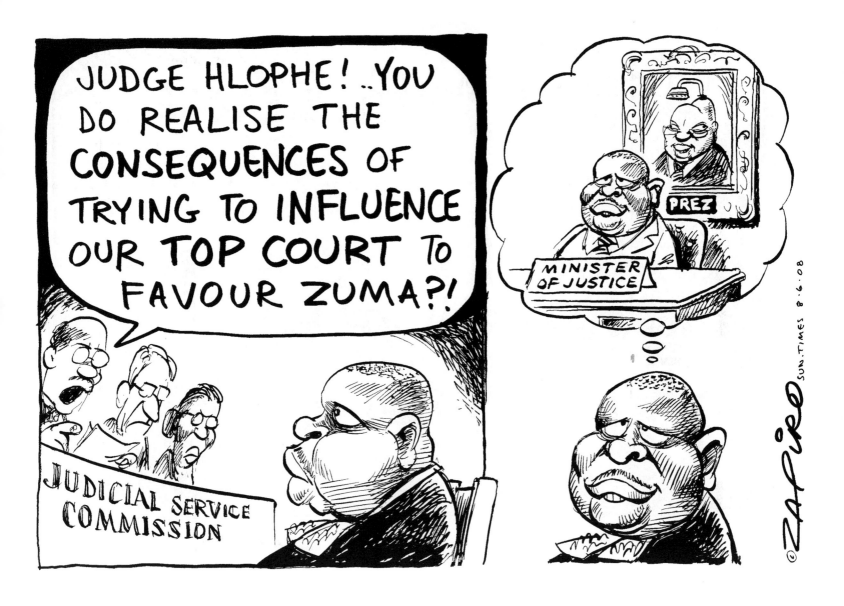

8 June 2008

The Constitutional Court has complained that Cape Judge President John Hlophe
improperly lobbied two Concourt judges in four cases involving Zuma and arms company Thint

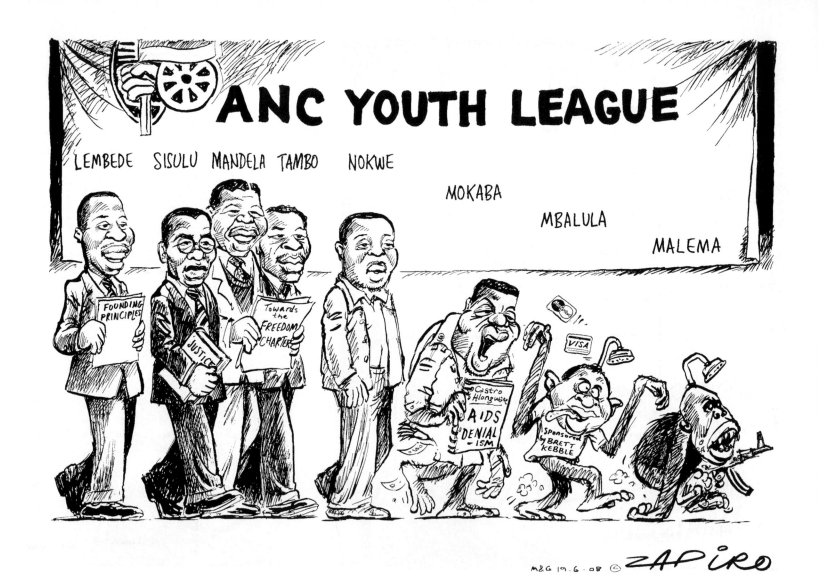

19 June 2008

If Zuma's corruption trial goes ahead, warns new ANC Youth League
president Julius Malema, then 'We are prepared to take up arms and kill for Zuma'

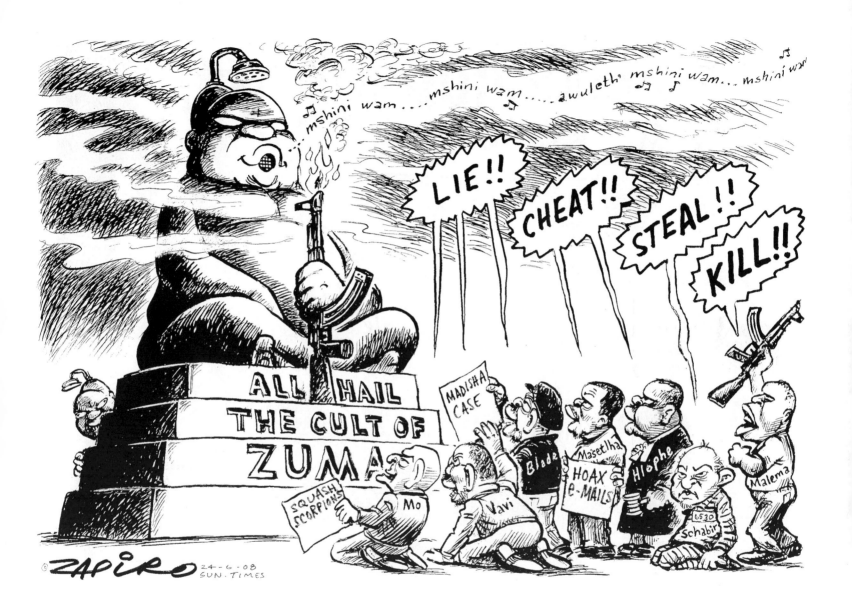

24 June 2008

Jockeying for positions, settling of anti-Mbeki scores and Cosatu's
Zwelinzima Vavi echoing the readiness to 'shoot and kill for Zuma'

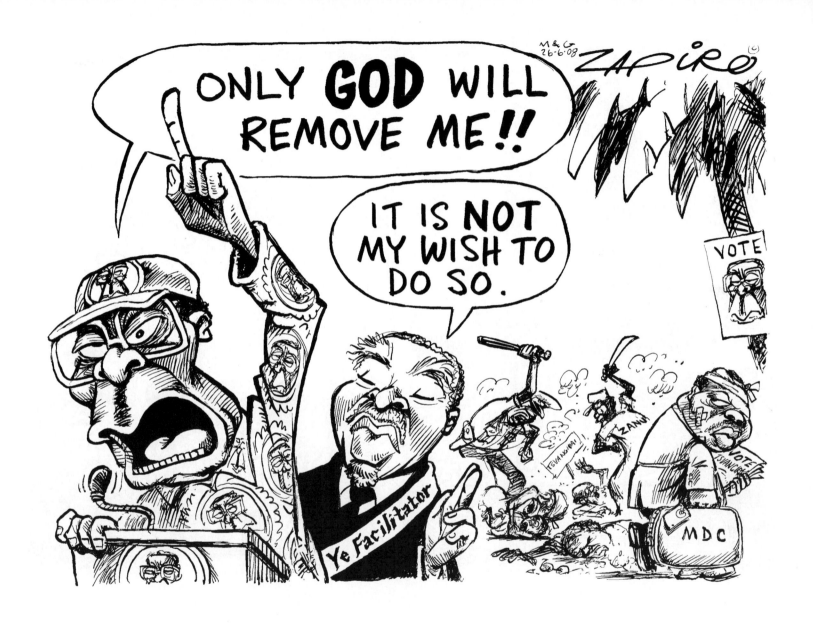

26 June 2008

'Only God' could remove him from office, declares Mugabe ahead of the presidential run-off election. Escalating violence causes Tsvangirai, the marginal winner of the March election, to withdraw.

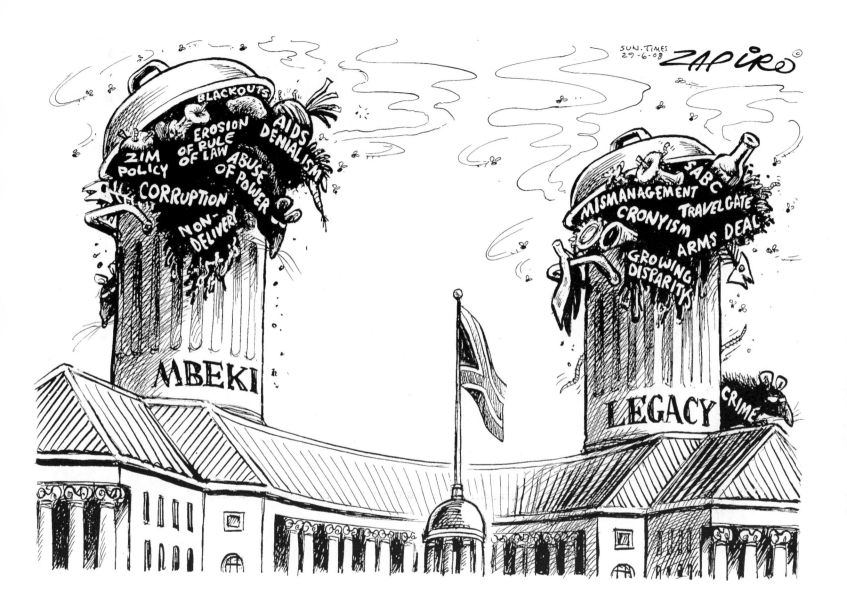

29 June 2008

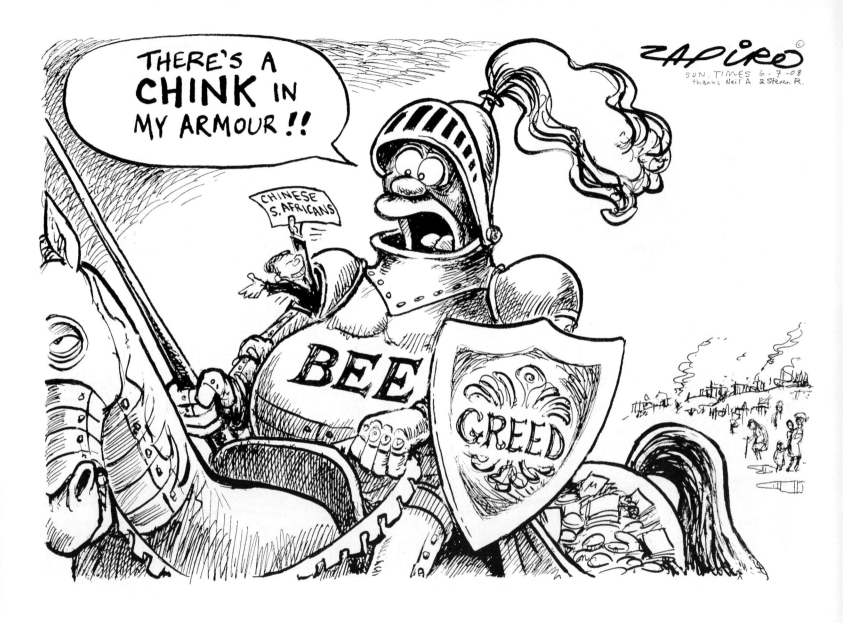

6 July 2008

Black business spurns the High Court ruling classifying Chinese South Africans as 'black people' who suffered apartheid discrimination and now qualify for business benefits

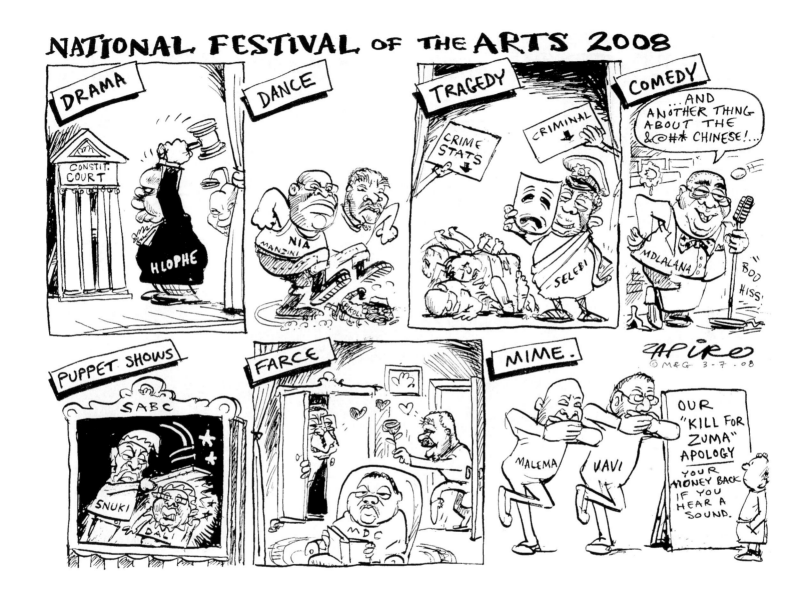

3 July 2008

Amongst other political shenanigans, Vavi and Malema brush
off the Human Rights Commission when it wants them to apologise

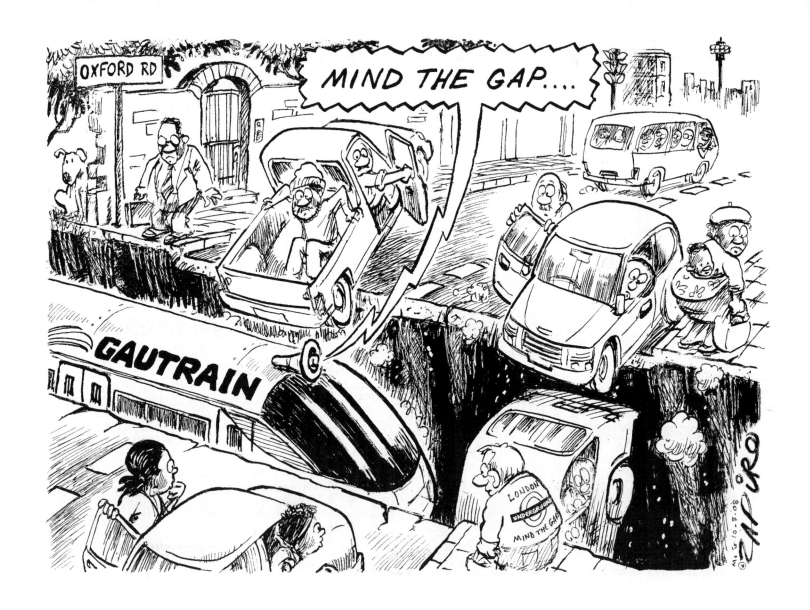

10 July 2008 Gautrain tunnelling causes a massive sinkhole in one of Johannesburg's busiest roads

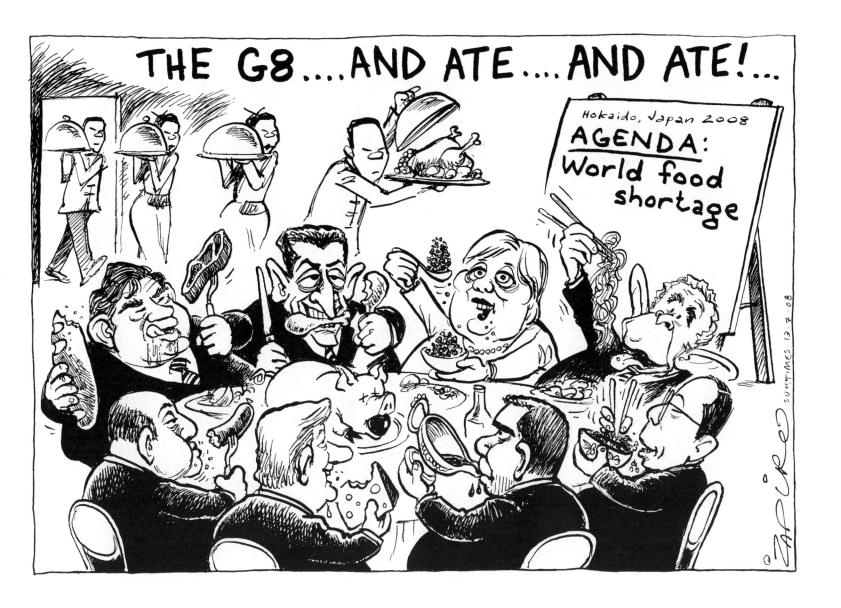

The G8 summit leaders discuss the global food crisis, make no firm commitments, then sit down to an eight-course, 19-dish dinner

13 July 2008

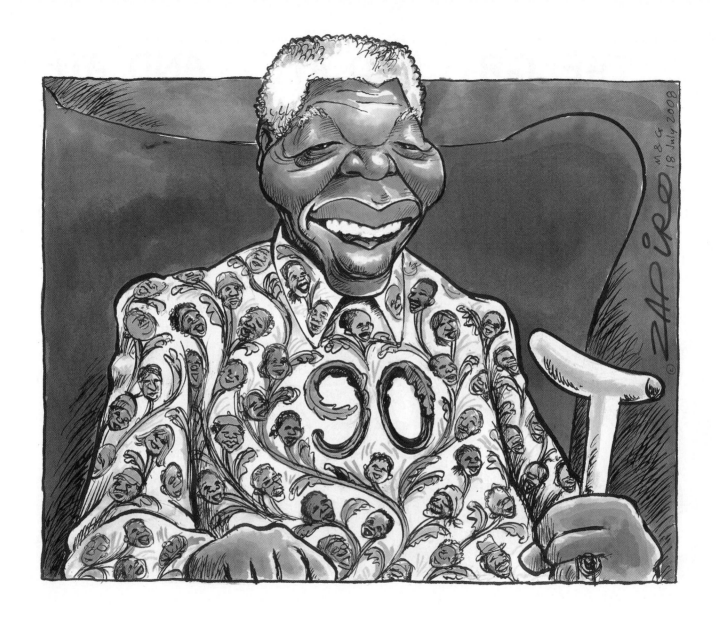

18 July 2008

Milestone birthday celebrated worldwide

Mandela has appeared in my cartoons as the child with the potential to become what he dreams of, as the prisoner embodying a nation imprisoned, as the banned face of the banned struggle, as David slaying the apartheid Goliath, as the bird breaking out of the apartheid cage, as the genie who won't get back in the bottle, as Moses parting POP!! the waters for the masses, and as Moses leading them into the promised land, as the sunrise at the dawn of the new South Africa, as the Colossus bestriding the national landscape, as the architect of democracy, as the rider in the saddle of the GNU, as the sculptor hewing racial harmony, as the fireman dowsing the flames of crises, as the acrobat anchoring a diplomatic balancing act, as Supermandela bridging global divides, as Atlas bearing the developing world, as the wind blowing the Springboks to victory, as a jar of Madiba Magic for Bafana Bafana, as the Mandela Bridge spanning the racial divide, as the grandfather dandling the infant nation, as the giant with massive shoes to fill, as the cowboy and his gal riding into the African sunset, as the tireless globetrotter outpacing all others, as the prisoner pushing open the Aids secrecy door, as the planet in the fight against HIV/Aids, as the beaming Nelson atop Nelson's Column, as the Cupid of the divided ANC, as the Conscience of the Nation, as the sun setting on his own era.

HAPPY 90th, MADIBA! ZAPIRO

SUN. TIMES 18 July 2008

18 July 2008

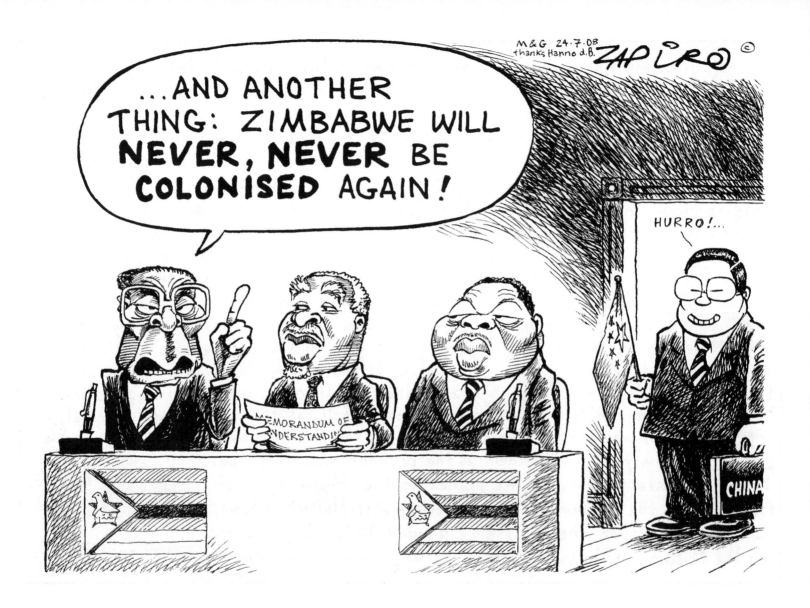

24 July 2008

Classic Mugabe rhetoric during signing of Mbeki-brokered power-sharing agreement

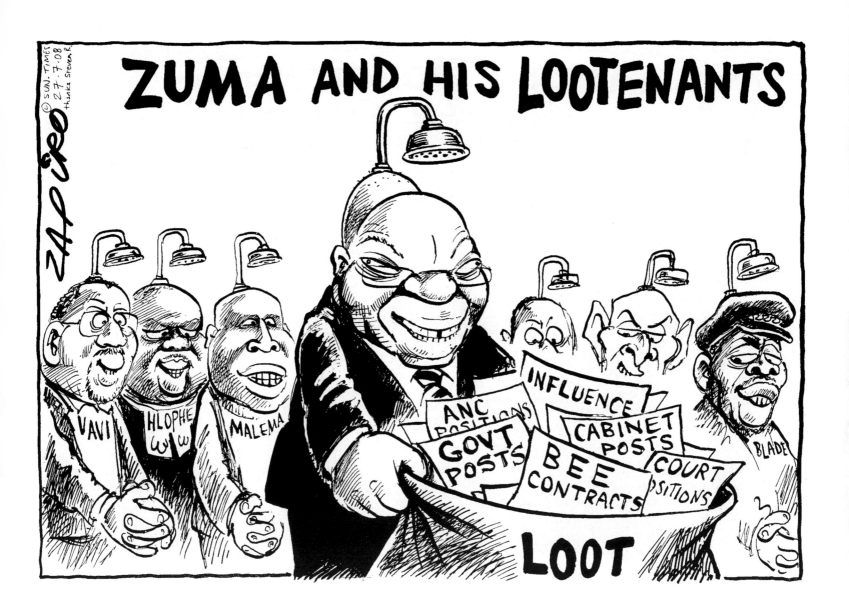

27 July 2008

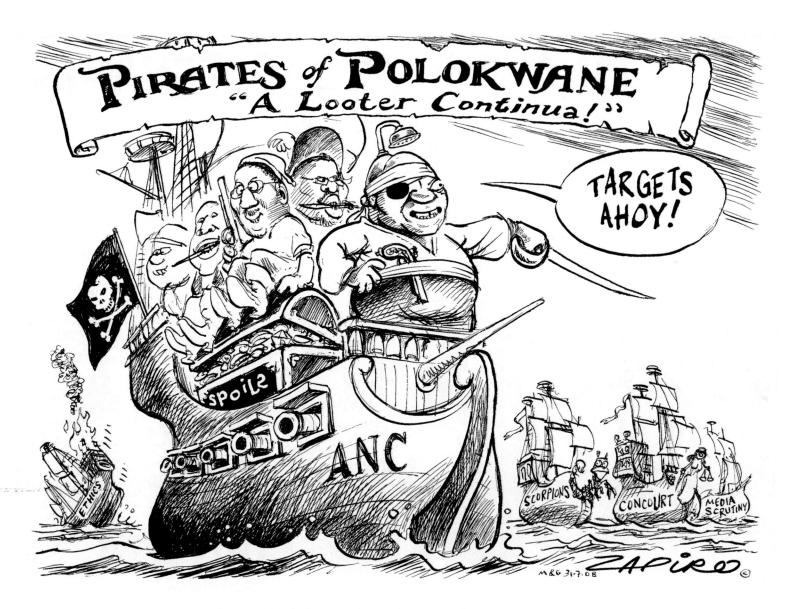

Anyone seen as an obstacle to a Zuma presidency comes under attack,
especially in the weeks since ANC secretary-general Gwede Mantashe
labelled Constitutional Court judges as 'counter-revolutionary'

31 July 2008

114

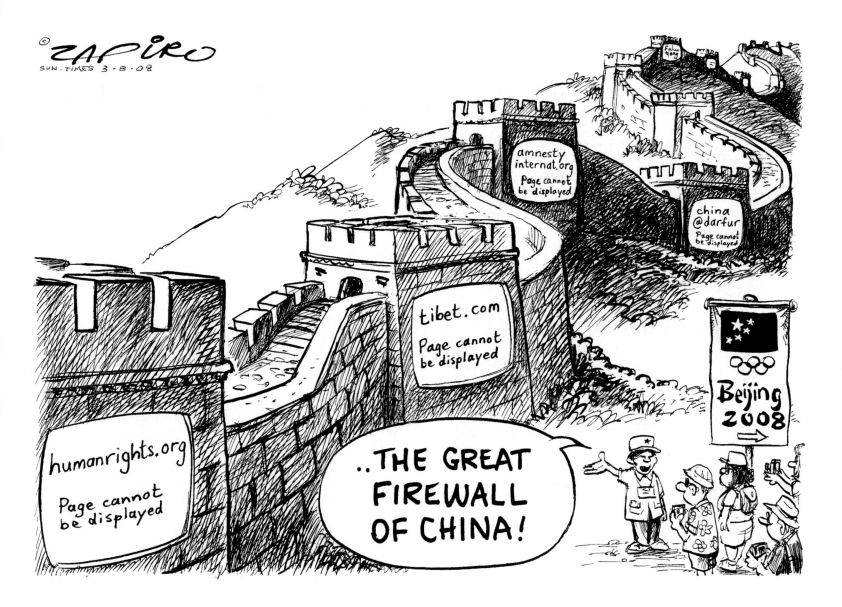

3 August 2008

Days ahead of the Olympics, it's revealed that Chinese authorities, with the collusion of the International Olympic Committee, are blocking 'sensitive' internet sites

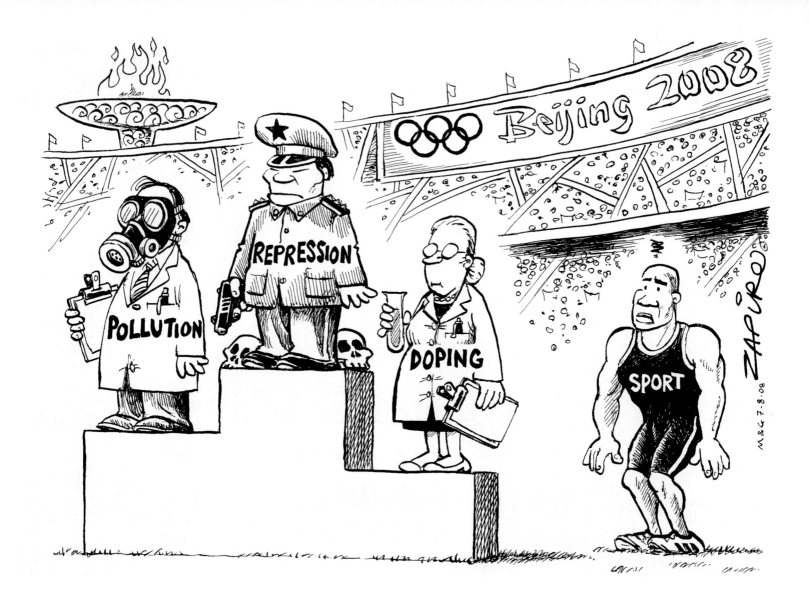

Let the Games begin

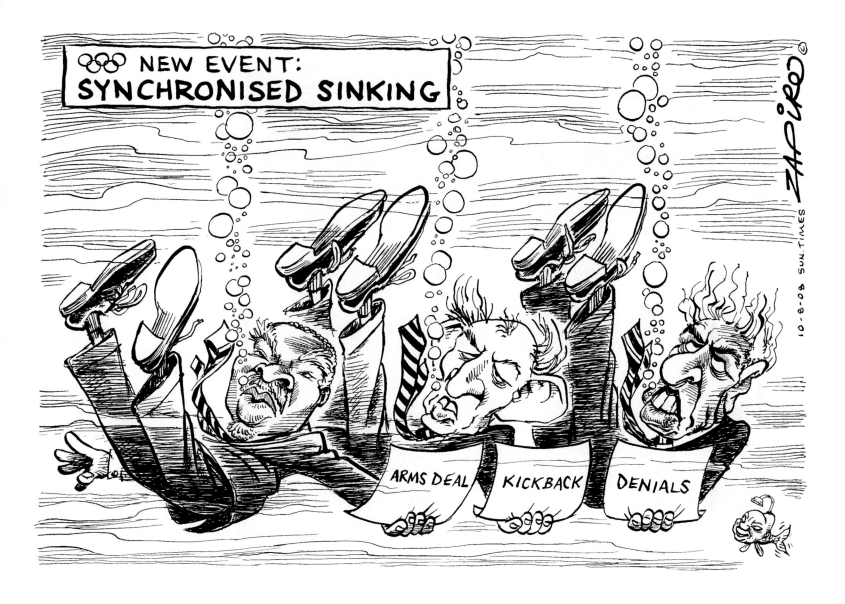

Media exposé alleges a German shipbuilding company paid a R30 million arms deal bribe to Mbeki, who slipped R2 million to Zuma and the rest to the ANC. Convoluted denials by Ministers Erwin and Pahad only heighten suspicion.

10 August 2008

117

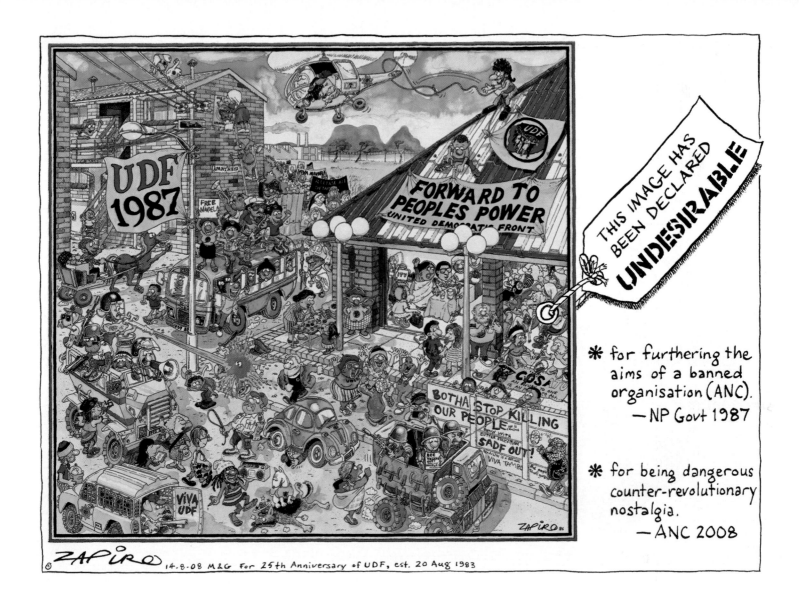

14 August 2008

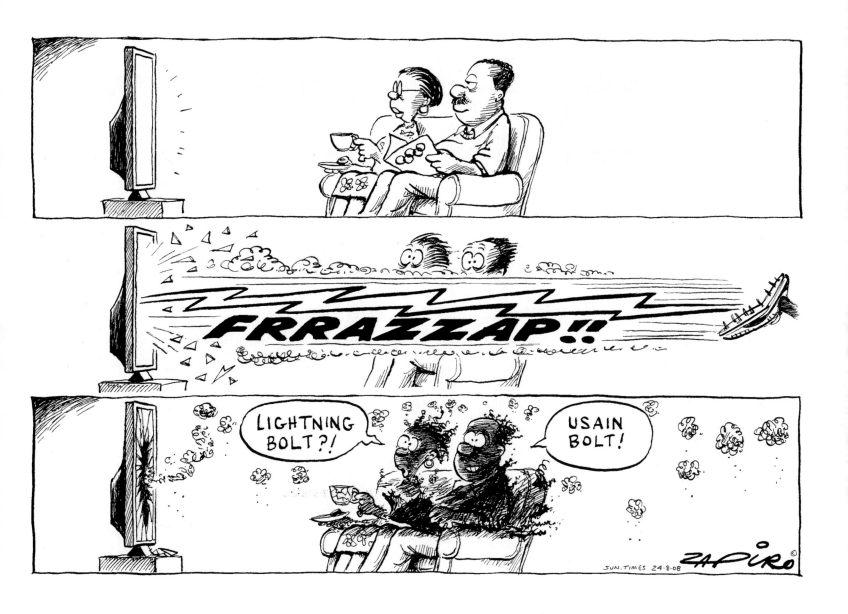

24 August 2008

Jamaican superman obliterates all opposition, becoming the first athlete to win the Olympic 100 m and 200 m sprint double and also set world records in both

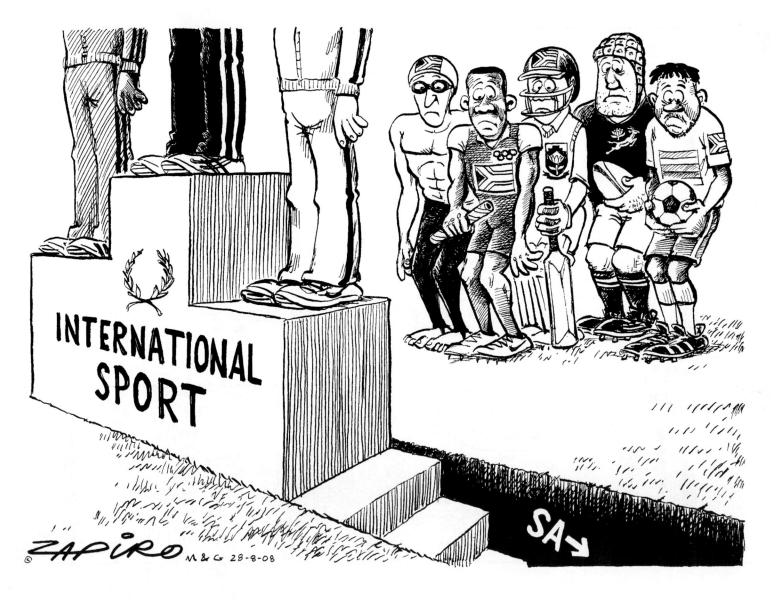

Team SA posts our worst-ever Olympic performance (63rd on the medals table),
the Proteas are bombing in England, the Boks slump from world champs to
Tri-Nations wooden spoonists and Bafana Bafana can't qualify for anything

28 August 2008

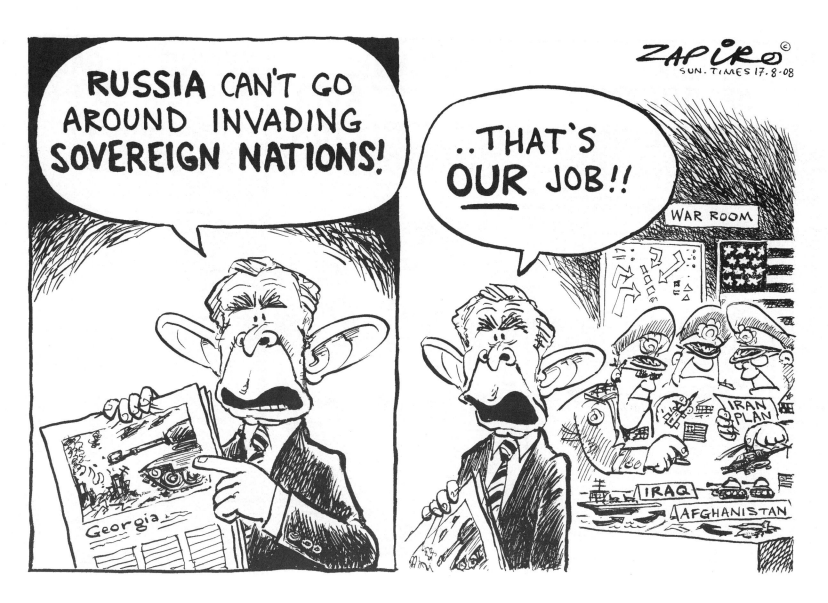

17 August 2008 Russian tanks enter Georgia's breakaway province, South Ossetia

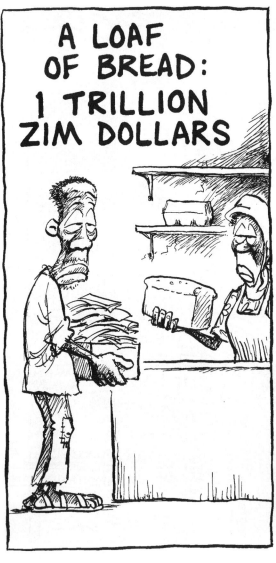

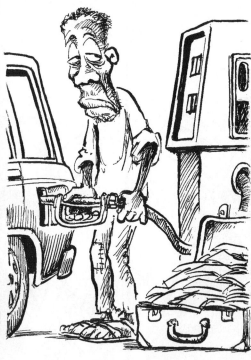

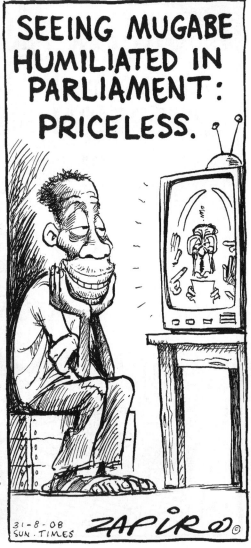

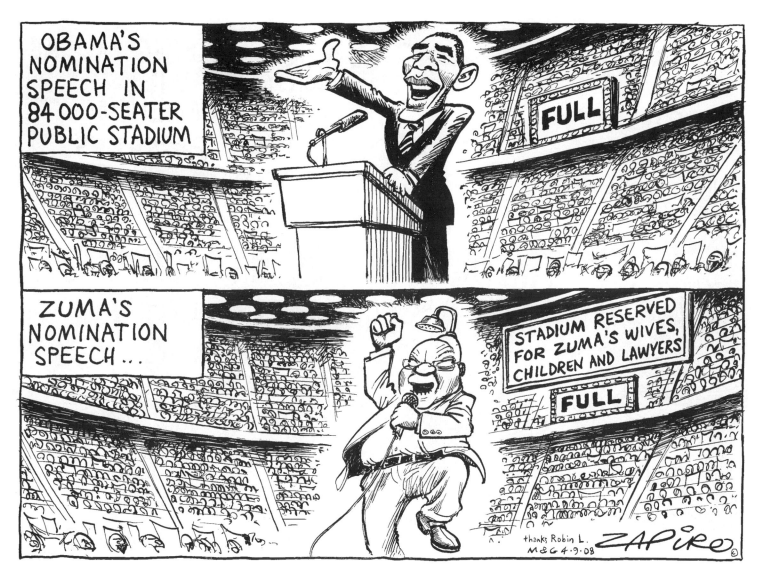

At the Democratic convention, the impressive
Barack Obama accepts nomination for the US presidency.
Meanwhile, a week before a court rules on whether the case against Zuma
can proceed, the ANC warns that if it does proceed, there'll be anarchy.

4 September 2008

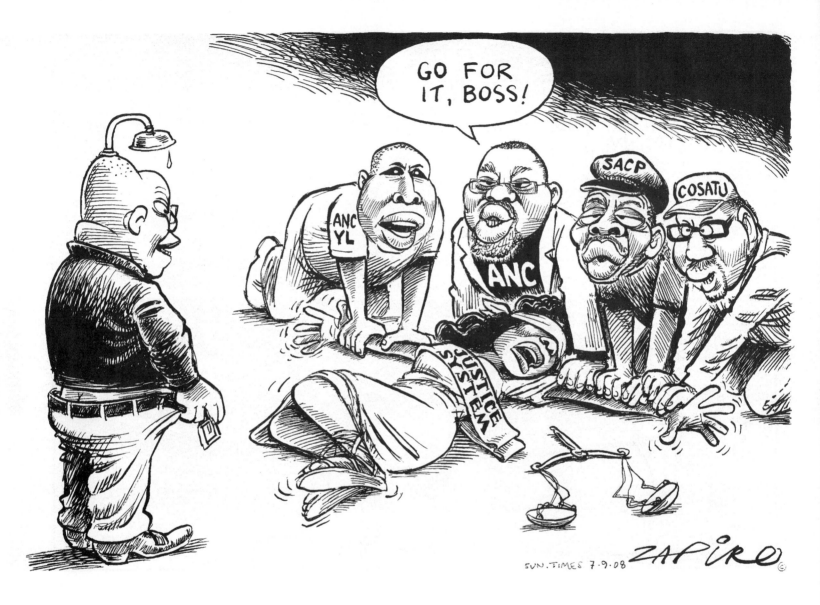

They've vowed to kill, demanded a 'political solution', threatened anarchy
and smeared and bullied judges. So, is this cartoon metaphor justifiable?
The cartoon makes headlines and debate rages through the media.

7 September 2008

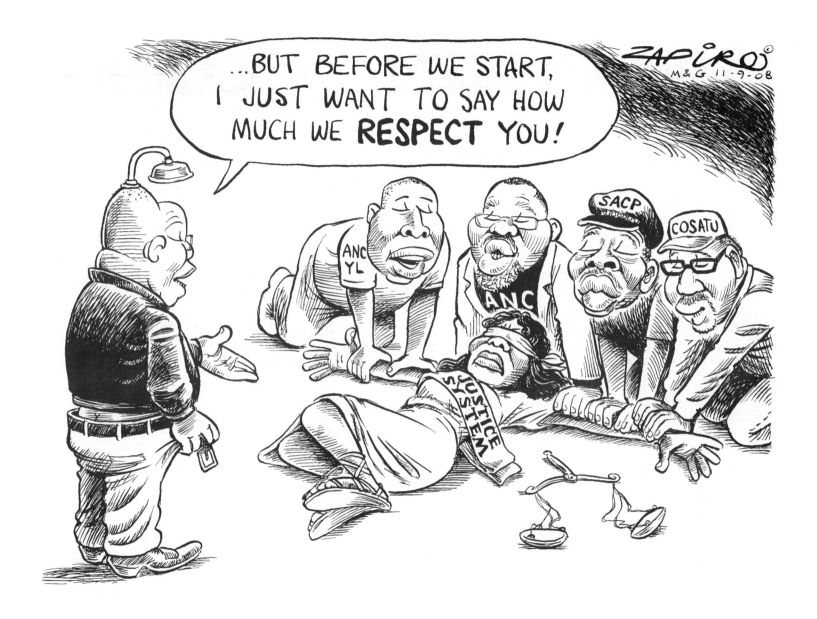

11 September 2008 A bit of spin: Zuma and Mantashe now declare their respect for the judiciary

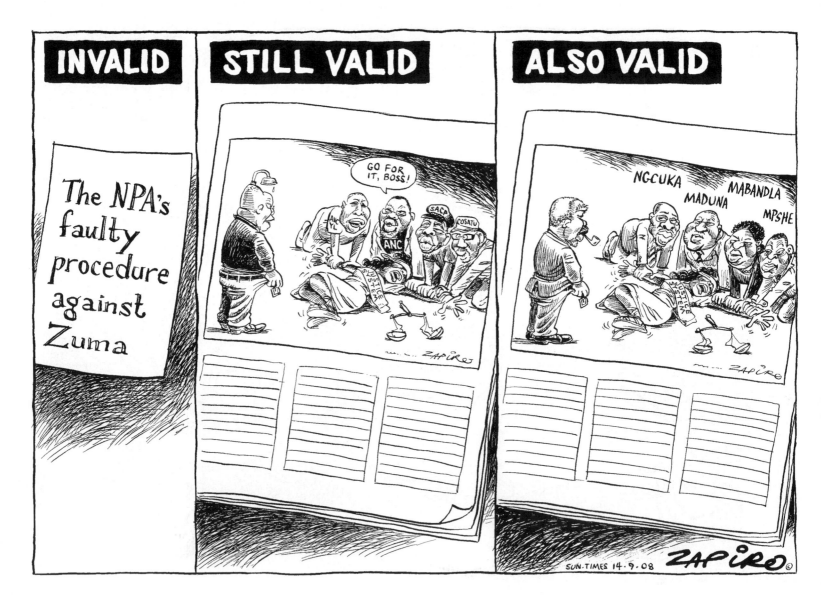

Victory for Zuma. Judge Chris Nicholson rules that
procedure was botched so badly as to invalidate the charges.
He also slams Mbeki and his legal cohorts for political interference.

14 September 2008

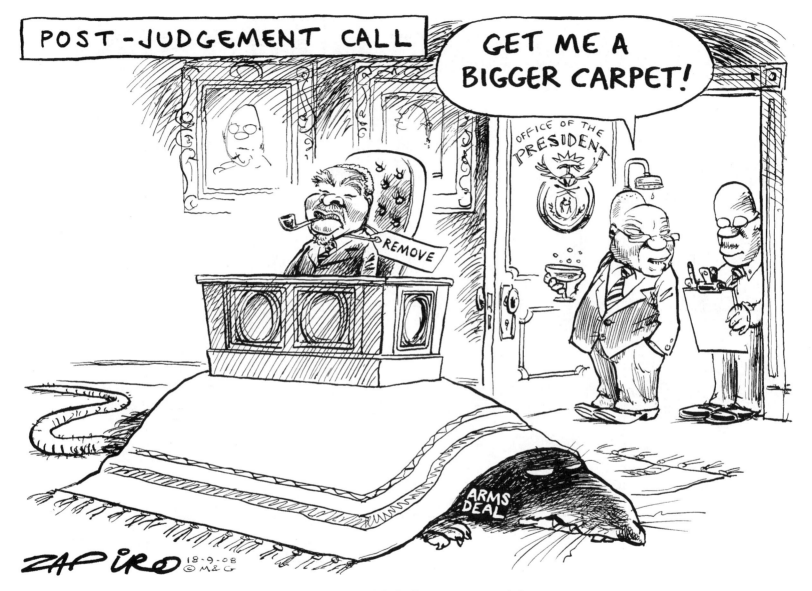

Knives are out for Mbeki. Zuma-camp triumphalism
conveniently ignores the part of Judge Nicholson's ruling
calling for a judicial inquiry into the arms deal.

18 September 2008

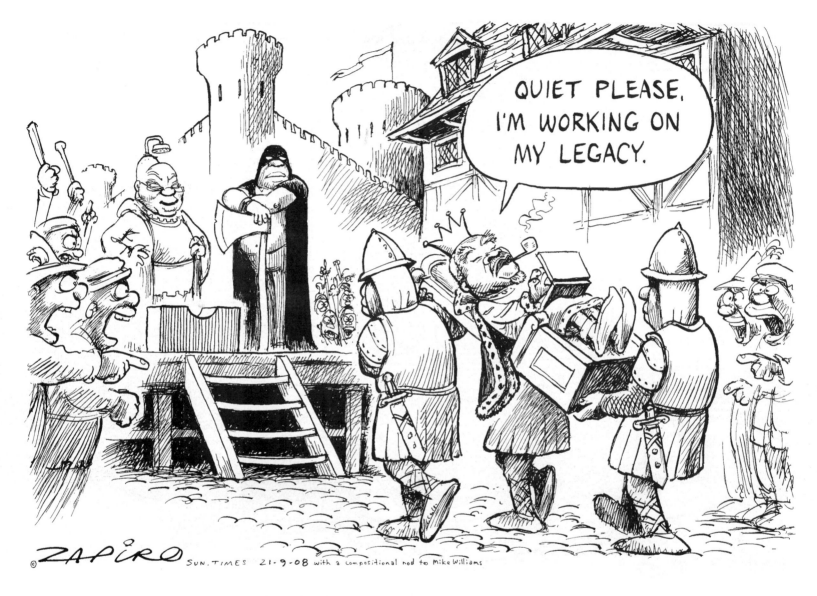

21 September 2008

When Mbeki says he'll appeal the judgement, the ANC
tells him to step down or be removed in parliament.
Within days he resigns. Some Cabinet allies go with him.

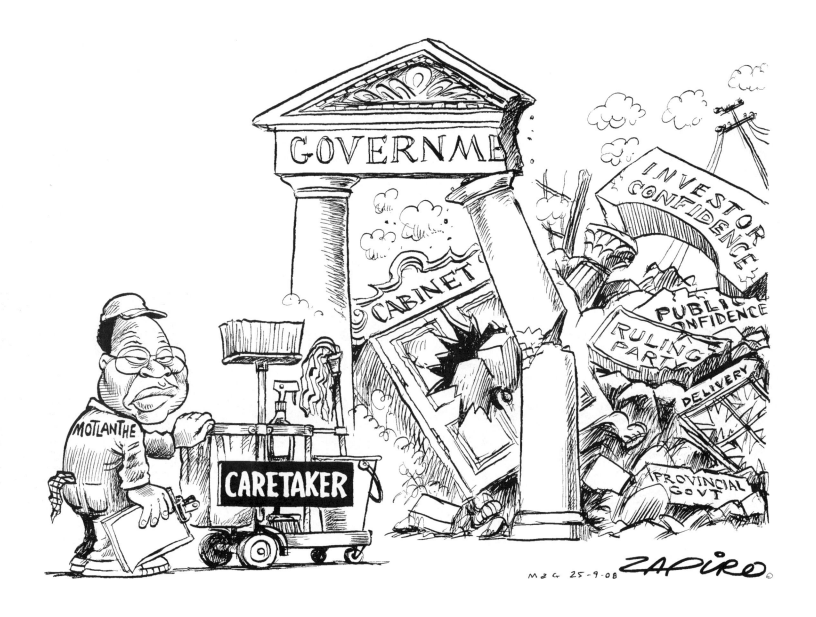

Respected ANC deputy president Kgalema Motlanthe is sworn
in to be the nation's 'caretaker' president until the 2009 election

25 September 2008

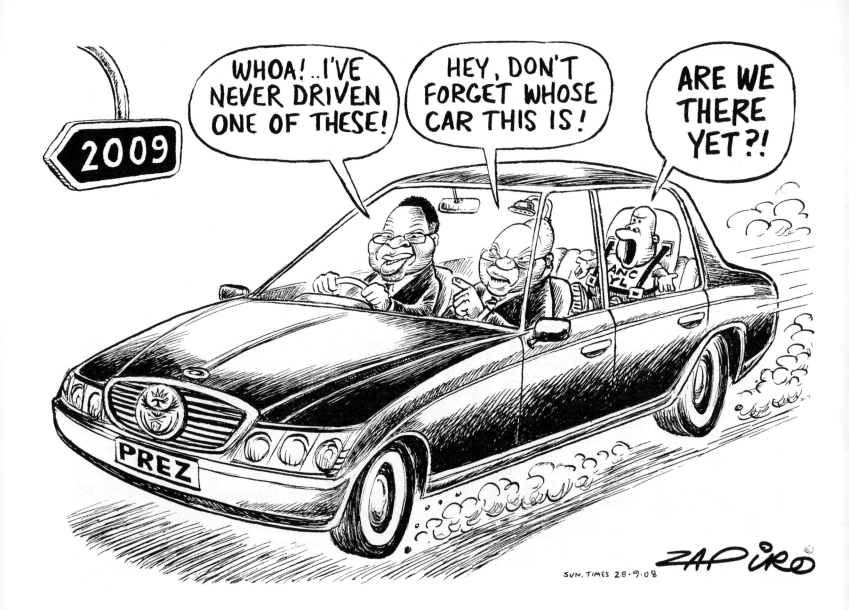

28 September 2008 Motlanthe begins well, making solid Cabinet appointments. Will he outshine Zuma?

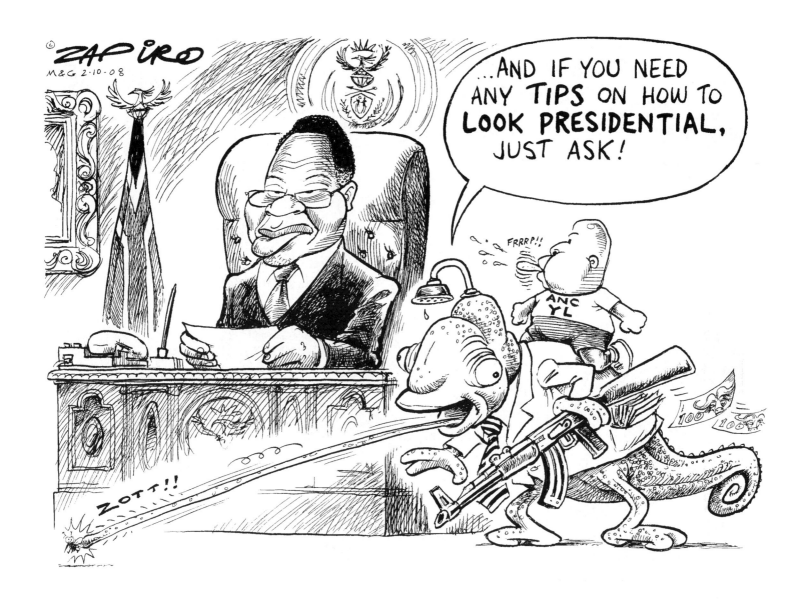

2 October 2008

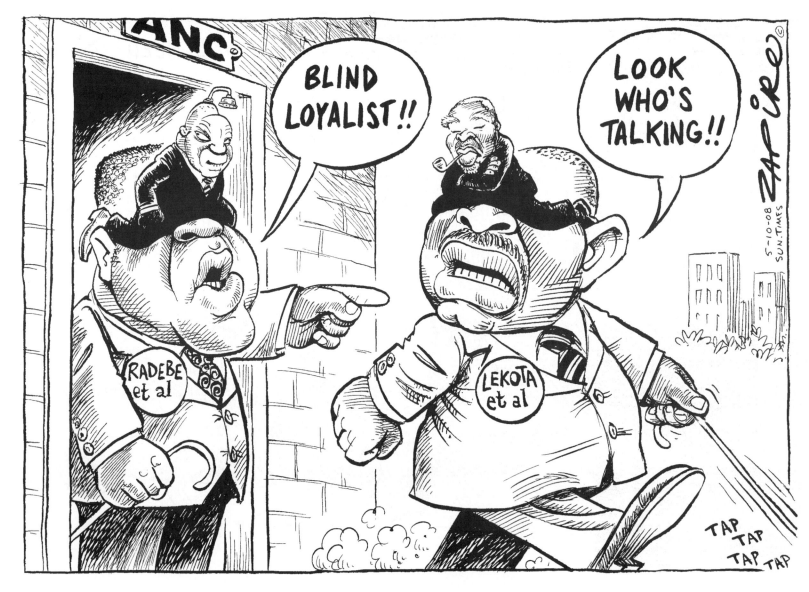

In an exchange of open letters, Terror Lekota slams the new ANC
leadership for attacking judges and Jeff Radebe says Lekota's grown
too big for the party. There's talk of an ANC breakaway faction.

5 October 2008

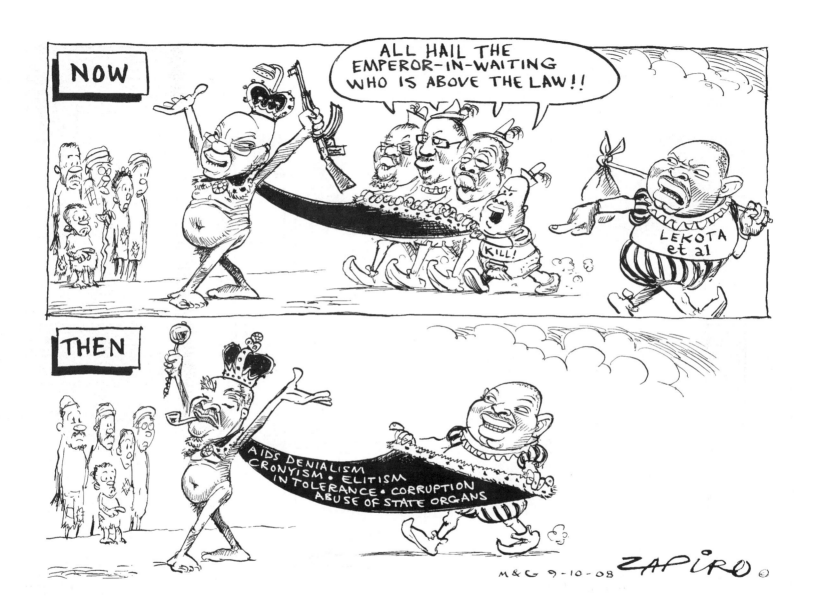

Lekota mobilises allies but stops short of forming a new party … just yet.
His righteous indignation is impressive. Pity about his own record as party chair.

9 October 2008

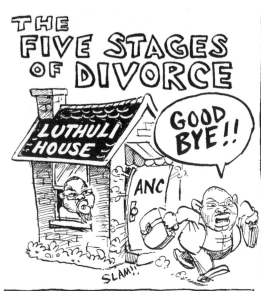

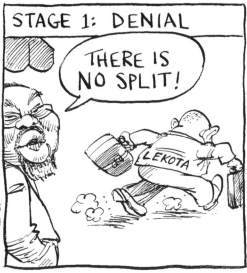

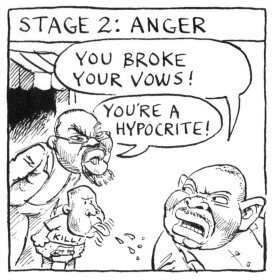

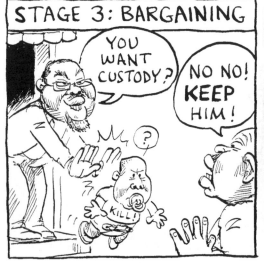

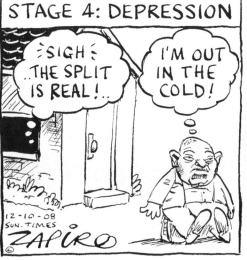

12 October 2008